IMAGES
of America

STAUNTON

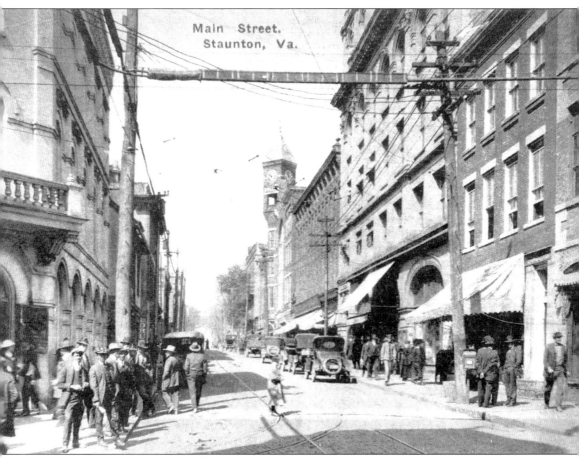

THE HEART OF STAUNTON C. 1906. This view of West Beverley Street *c.* 1906 shows a group of buildings that all survive in downtown Staunton.

IMAGES
of America

STAUNTON

Sergei Troubetzkoy

ARCADIA
PUBLISHING

Copyright © 2004 by Sergei Troubetzkoy
ISBN 978-0-7385-1697-4

Published by Arcadia Publishing
Charleston, South Carolina

Printed in the United States of America

Library of Congress Catalog Card Number: 2004108736

For all general information contact Arcadia Publishing at:
Telephone 843-853-2070
Fax 843-853-0044
E-mail sales@arcadiapublishing.com
For customer service and orders:
Toll-Free 1-888-313-2665

Visit us on the Internet at www.arcadiapublishing.com

*This book is dedicated to the memory of my mother, Ulrich Troubetzkoy,
who fostered my love of history and architecture.*

CONTENTS

ACKNOWLEDGMENTS

I gratefully acknowledge the following individuals and organizations for their assistance with this project: Richard Hamrick, Frank Strassler, the Historic Staunton Foundation, Kimberly Watters, Brian Green, Camera and Palette, Inc., the Staunton Performing Arts Center, the Theatre Historical Society, and Carter Green of Frazier Associates.

INTRODUCTION

For more than a century, Staunton has been known as the "Queen City of the Shenandoah Valley," not only because of its economic and geographic location in the heart of the Shenandoah Valley, but also because of its architectural beauty. Since the early 1800s, prominent architects and builders have left their marks on the hilly terrain of Staunton, creating a rich architectural fabric rarely found in small American towns.

Once the largest community in western Virginia, Staunton was located in the center of the state until the creation of West Virginia in 1862. A major economic and transportation hub throughout the 19th and early 20th centuries, the town was home to affluent people and prosperous businesses with the resources to build handsome buildings.

Due to the fact that the Shenandoah Valley was one of the first American frontiers, most early buildings were simple log structures. Staunton was settled primarily by Scotch-Irish and Germans who came via Pennsylvania down the Great Wagon Road and later the Valley Turnpike. Because of this, the early architecture of the valley was quite different from that of eastern Virginia.

Many architecturally significant buildings were constructed in Staunton at the end of the 18th century. The first of these was the Augusta Parish Church erected around 1762 out of brick, a material that would be used rarely until the end of the century. The building, located where the Trinity Episcopal Church stands now, is believed to have resembled other simple churches in Virginia during that era.

One of Staunton's first brick dwellings, a small gambrel-roofed cottage that survives in the Newtown neighborhood, was built by Judge Archibald Stuart around 1785. His family lived in this cottage while construction took place on their imposing classical revival–style mansion. Stuart may have been responsible for initiating Staunton's close ties with Thomas Jefferson, who had a noticeable influence on the town's architectural aesthetic. Prominent Staunton residents who worked for Jefferson included Dabney Cosby and Thomas Blackburn.

Dabney Cosby, who lived in Staunton during the late 18th and early 19th centuries, was the earliest known brick manufacturer in the town. During the early 19th century, his brickyard was located on the northeast corner of New and Frederick Streets; this site later became home to the original building of Mary Baldwin College. Cosby owned various parcels of land in Staunton, and after leaving to work in other parts of Virginia and North Carolina, he returned to visit the area several times.

Architect Thomas Blackburn, who resided in Staunton much longer than Cosby, was taken under Jefferson's tutelage and allowed to borrow architecture books from Jefferson's personal

library. Both Cosby and Blackburn worked for Jefferson on the construction of the University of Virginia, and they would continue to design Jeffersonian neo-classical buildings long after Jefferson's death.

Throughout his career in public service as a legislator, governor, and President, Thomas Jefferson argued that governmental buildings should serve as a model for the private sector; early state and federal buildings reflected his belief in design excellence. Both the Western Lunatic Asylum (later Western State Hospital) and the Virginia School for the Deaf and Blind (VSDB) established an architectural precedent in Staunton. Dabney Cosby and Thomas Blackburn were both actively involved with the Western Lunatic Asylum project, which began in 1828 shortly after the completion of the University of Virginia complex. Blackburn continued to work on Staunton buildings for several decades, including those at Western State and VSDB.

Cosby and Blackburn were not alone in shaping the fabric of Staunton. Several notable Baltimore architects were involved in major projects in the city, such as William Small, who designed the original building for Western State Hospital, and Robert Cary Long Jr., who designed an extraordinary Greek revival temple for VSDB. Thomas Blackburn became actively involved in both of these projects; he planned major additions to the main building at the mental facility such as a chapel and other structures. A prominent Baltimore architect, Norris G. Startweather, designed a handsome home for the Cochran family on Frederick Street during the 1850s.

During the 1830s, Thomas Blackburn designed a magnificent Augusta County Courthouse that has been called one of the most Jeffersonian courthouses ever built in the state. That building was altered beyond recognition in 1901 by T.J. Collins. Several significant classical revival–style buildings were constructed from around 1820 until the advent of the Civil War; these are attributed to Blackburn, as they possess characteristics of his style. Possible Blackburn designs include the main building of Mary Baldwin College, the Presbyterian Manse (birthplace of Woodrow Wilson), and Selma, a private home. The classical revival style initiated by Archibald Stuart dominated the aesthetic of Staunton for much of the 19th century.

Staunton's most famous architect, T.J. Collins, moved to Staunton in 1890 to work for the Staunton Development Company, which failed the following year. He later set up practice with another architect before branching out on his own. Collins, who had practiced architecture in Washington, D.C., made his mark in Staunton. He and his two sons, both talented architects, transformed the look of their adopted city with some 200 buildings designed in a wide variety of styles, from Queen Anne, châteauesque, French Second Empire, bungalow, Beaux Arts, mission, and revivals of Italian Renaissance, Tudor, Romanesque, and Colonial styles, to name a few. Most of their buildings are now treasured landmarks, and the architectural drawings and plans for these buildings survive as one of the finest collections in the world. These plans will be housed in the R.R. Smith History and Art Center, designed by the firm as a hotel in the 1890s.

One

THE EARLY YEARS

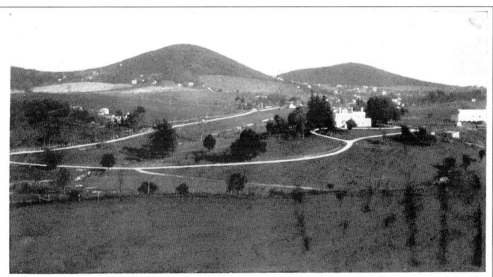

BETSY BELL AND MARY GRAY, STAUNTON, VA. These beautiful twin hills were named by the pioneer Scotch-Irish settlers of Augusta County after two hills of their beloved County Tyrone, Ireland. The Ireland hills had been named for two beautiful Scotch lassies of aristocratic birth, who, according to legend, left their respective homes and lived in a bower in an effort to escape a great plague. However, they died after contracting the disease from a young man who loved them both and carried them food. The tragic story was preserved in a ballad, popular in its day, which accounts for the popularity of the names.

BETSY BELL AND MARY GRAY MOUNTAINS. These two small mountains have always dominated the landscape of Staunton. The large house seen below the mountains was Gaymont, an important house that was built in the early 19th century and demolished during the early 1970s.

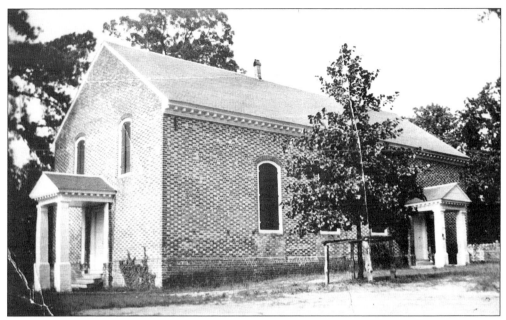

OLD FORK CHURCH IN HANOVER, VIRGINIA. Although no images survive of the original Augusta Parish Church building in Staunton, it is believed to have looked similar to this one, which was constructed by the same builder, Francis Smith. In 1781, the Virginia legislature was forced out of the capitol in Richmond by British forces under the command of Col. Banastre Tarleton. The displaced government officials moved to Staunton where they met in the Augusta Parish Church, the largest building in town at the time, from June 7 to June 23. Members of the legislature, including Patrick Henry and Daniel Boone, elected Thomas Nelson as the new governor to succeed Thomas Jefferson. (Courtesy of Historic Staunton Foundation.)

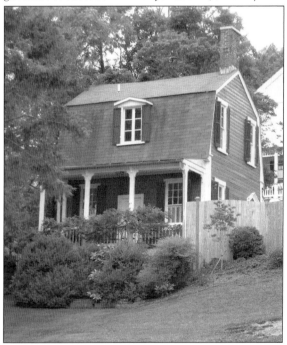

STUART LAW OFFICE. Around 1785, Archibald Stuart built a small gambrel-roofed cottage for his family in Newtown while work proceeded on his house next door. This cottage was typical since most houses of the era were small and built of either frame log or stone. After the neighboring mansion was completed, Stuart maintained the cottage as his office. (Courtesy of Historic Staunton Foundation.)

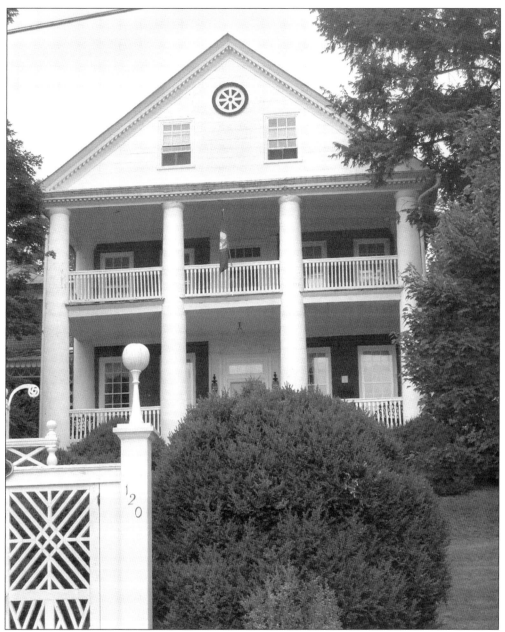

STUART HOUSE. Unlike other land parcels in Newtown, this property originally included the entire city block. When Archibald Stuart's new home was completed in 1791, it must have been very imposing indeed with its two-story pedimented portico overlooking the center of town. Classically inspired houses would eventually become popular in Staunton, but not for several decades. Stuart built his home in a vernacular version of classicism, a style popularized by his close friend Thomas Jefferson. This remarkable house has a large extension to the south that was added by Archibald's son, Alexander H.H. Stuart, a leading figure in 19th century Virginia who served as secretary of the interior in the administration of Millard Fillmore. This house has remained in the family for more than two centuries. (Courtesy of Historic Staunton Foundation.)

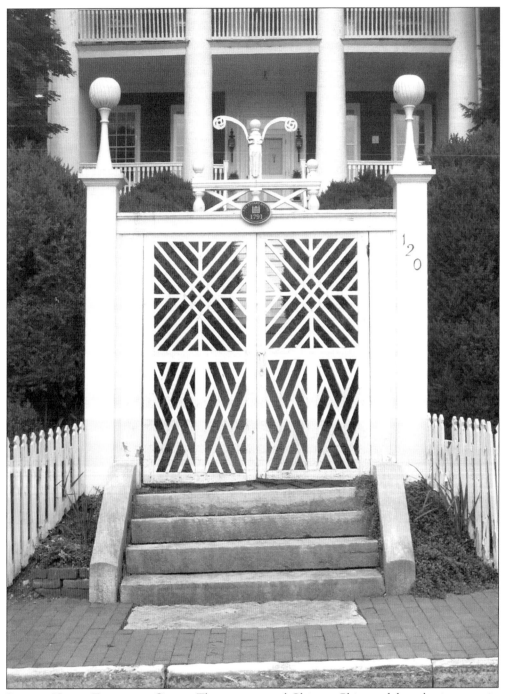

STUART HOUSE ENTRANCE GATES. The monumental Chinese Chippendale or lattice gates in front of Stuart House date from 1791 when the main house was completed.

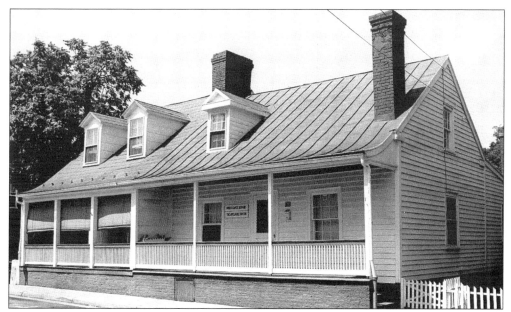

SMITH-THOMPSON HOUSE. The left portion of this house was built around 1792 and is one of Staunton's few remaining 18th century structures. It and Stuart House, just a few blocks away, were two of the earliest brick buildings. Most homes of this era were either frame or log construction. The right section of this house was added during the 19th century. (Courtesy of Historic Staunton Foundation.)

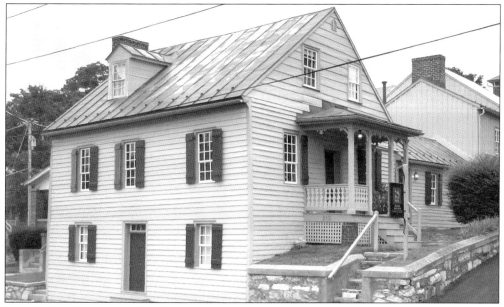

TROTTER'S TAVERN. Built c. 1800, this log building was originally covered with clapboards, as were many log constructions of the era. Many of Staunton's late 18th and early 19th century buildings probably resembled this one in size and form. For many years during the 19th century, this served as a stagecoach stop on the busy Valley Turnpike. It has had a number of additions over the years; the most substantial extension was in 2003 and 2004 to accommodate the growing architectural practice of Frazier Associates.

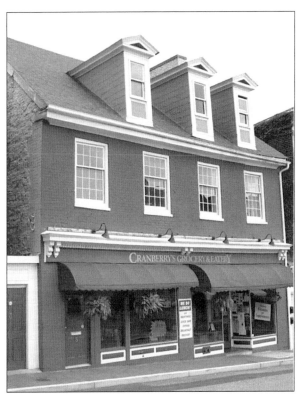

3-7 SOUTH NEW STREET.
Downtown Staunton's lone
surviving stone house, probably
built at some point during the
second half of the 18th century,
was greatly altered during the 19th
century when a new brick façade
was added and the interior was
transformed c. 1835.

3-7 SOUTH NEW STREET. The
original side and rear stone walls
survive, and when viewing the
building from one of the upper
levels of the nearby New Street
parking garage, one can get a feel of
how this house must have originally
appeared. Stone houses built during
the 18th and early 19th centuries
were once common throughout the
Shenandoah Valley.

Two

STAUNTON BEGINS TO PROSPER

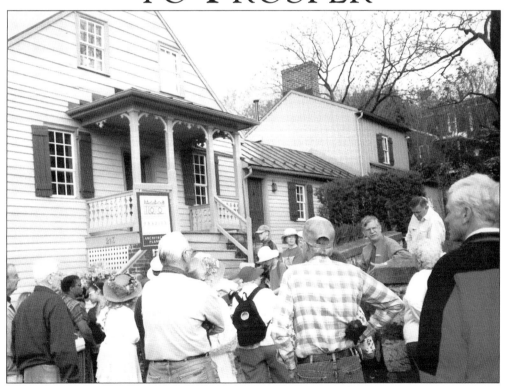

TROTTER'S TAVERN. Walking tour participants in 1999 examine historic Trotter's Tavern. The earliest potion, to the left, was built *c.* 1800 of log construction covered with boards, and to the right is a mid-19th century board and batten addition. In 2004, more additions have been made to accommodate the offices of a growing architectural firm, which occupies the site.

THE VALLEY HOTEL. Built *c.* 1815, this handsome, Federal-style brick building was used for many years during the 19th century as the Valley Hotel. At the end of the century and the beginning of the 20th, it was used as headquarters for the Lily of the Valley Elks Lodge and served as a community center for the African-American community.

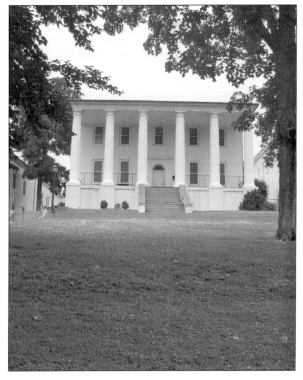

HILLTOP. One of Staunton's oldest surviving mansions from the 19th century, this once elegant house was built *c.* 1815 with a massive two-story portico, six Tuscan columns, and a delicate Federal-style cornice and entrance doorway. Prominently situated on a steep hillside overlooking the town, this mansion was the first large dwelling built in the Stuart Addition, a neighborhood established following the donation of land to the town by Judge Archibald Stuart. This was home to Circuit Judge Lucas P. Thompson from 1842 until his death in 1866, and in 1872, it was acquired by Augusta Female Seminary (now Mary Baldwin College). In 1904, T.J. Collins added an enormous wing to the rear of the structure.

EARLY 19TH CENTURY HOUSE ON AUGUSTA STREET. Although it looks as though it was constructed around 1815, it was actually constructed probably during the early 1830s in a vernacular version of the Federal style, as is seen elsewhere in Staunton. The frame house is fairly simple in its design with most detailing around the entrance doorway which has a graceful fanlight above, fairly typical features on Federal style houses.

JAMES POINTS HOUSE. Built in 1830, this house reflects the vernacular style of earlier homes in the region. Remarkably intact, the structure has undergone major alterations such as larger window panes, Victorian trim added to the porch, and a frame wing added in 1909. James Points was a founding trustee of the Virginia Female Institute, which is now Stuart Hall; a founder of Thornrose Cemetery; and a vocal opponent of slavery. The Points family members were tin and coppersmiths. They were also active in civic affairs.

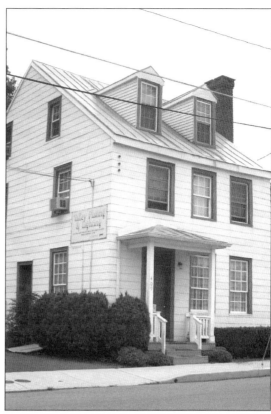

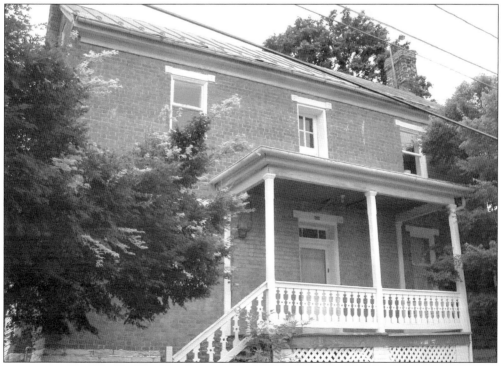

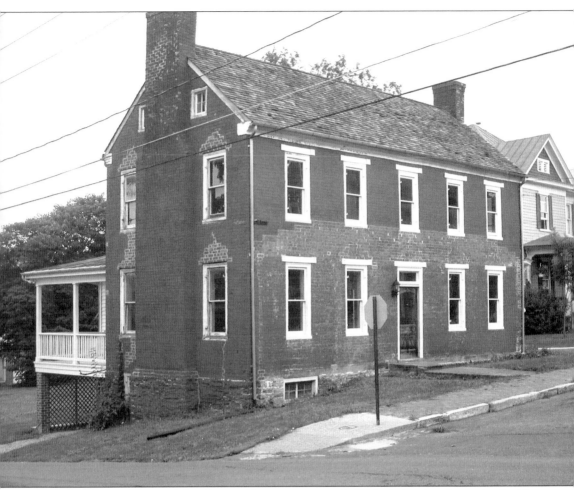

JOHN GROVE HOUSE. Most lots in Newtown were a half block in size; the main dwellings were constructed on a corner of the lot adjacent to an intersecting street, with outbuildings and gardens taking up the remainder of the property. This house in Newtown was built by John Grove in 1839 on such a lot and stylistically looks back to houses of two decades prior.

Three

GROWTH OF SCHOOLS AND INSTITUTIONS

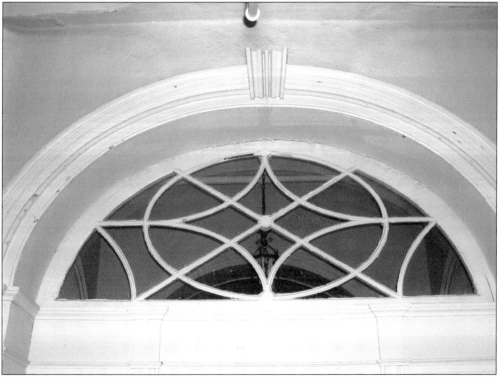

WESTERN LUNATIC ASYLUM, FANLIGHT. The original building for the hospital was constructed in 1828 by workers who had just completed work on Thomas Jefferson's University of Virginia. The design of many of the interior details at the Western Lunatic Asylum, such as this interior fanlight, are very similar to those used at the University of Virginia.

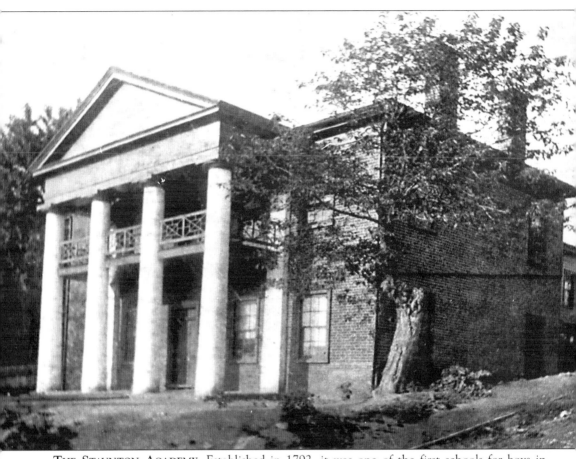

THE STAUNTON ACADEMY. Established in 1792, it was one of the first schools for boys in the Shenandoah Valley. Around 1810, a school with a Masonic Hall on the second floor was constructed at the intersection of New and Academy Streets where it remained until 1924. The portico shown in this late 19th century photograph is believed to have been added in the 1840s during the construction of the nearby Augusta Female Seminary. The Staunton Academy became a victim of the Civil War, but in 1870, the building served as the birthplace of the Staunton Public School system. One of the former school walls still exists today as a retaining wall. (Courtesy of the Hamrick Collection.)

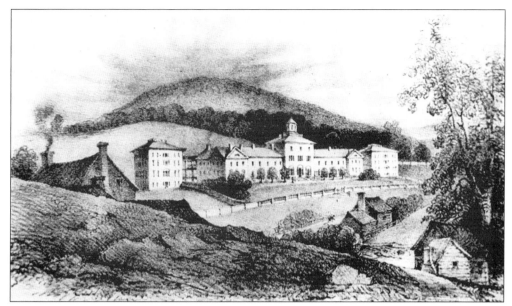

WESTERN LUNATIC ASYLUM. Now known as Western State Hospital, Western Lunatic Asylum was built in 1828 as a branch of America's first mental hospital in Williamsburg. Baltimore architect William Small, who had worked with the famous architect Benjamin Latrobe, designed this handsome, original five-part-plan hospital, a form used by other hospitals of the era including the Pennsylvania Hospital in Philadelphia. This building is believed to be the oldest mental hospital building surviving in the United States and perhaps in the western hemisphere. The illustration is c. 1838.

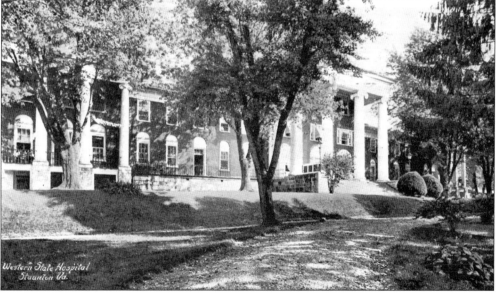

WESTERN LUNATIC ASYLUM MAIN BUILDING. This view c. 1912 shows the main building's monumental portico added in 1847 by Staunton architect Thomas Blackburn, who studied architecture under Thomas Jefferson. The Greek Ionic portico with cast iron capitals was added to the central section of the main building, and smaller pedimented porticos were added to the two wings. For approximately 10 years, Blackburn worked on various projects at the hospital.

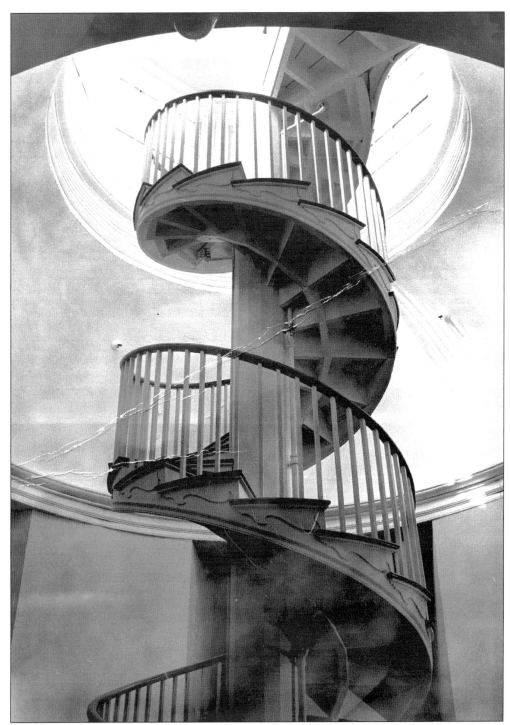

SPIRAL STAIRCASE IN THE WESTERN LUNATIC ASYLUM MAIN BUILDING. The main building at Western Lunatic Asylum has a remarkable free standing spiral staircase that seems to twirl like a corkscrew from the third floor to a cupola. This is an extraordinary example of the 19th century art of joinery.

CUPOLA WINDOWS IN THE WESTERN LUNATIC ASYLUM MAIN BUILDING. The spiral staircase leads to the cupola and an observation area with magnificent views of Staunton and the park surrounding the hospital. The glass-enclosed cupola allows natural light to pour into the interior space below and allows for the circulation of fresh air.

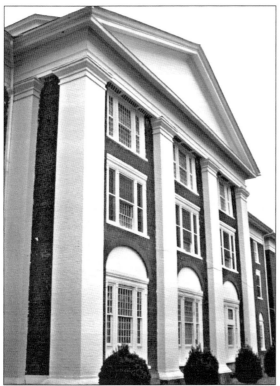

WESTERN LUNATIC ASYLUM (WARDS D, E, AND F). Another prominent Baltimore architect, Robert Cary Long Jr., designed two flanking buildings, which were built in 1840 and 1842 by William B. Phillips, a contractor who had helped build the University of Virginia complex for Thomas Jefferson. The building housing Wards D, E, and F has Chinese trellis work along the roof similar to that used by Jefferson at the University of Virginia.

THE NORTH WARD AT WESTERN LUNATIC ASYLUM. One of the two major structures at the hospital designed by Robert Cary Long Jr. of Baltimore was the North Ward. Long planned for the northern façade of this structure with a pedimented gable supported by Doric pilasters to provide a harmonizing vista from the Virginia School for the Deaf and Blind (VSDB), which he also designed.

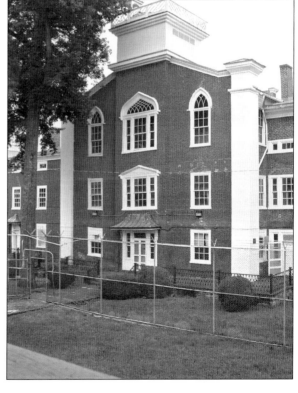

THE REFECTORY AND CHAPEL AT WESTERN LUNATIC ASYLUM. The chapel is located on the top floor of the refectory and chapel building. The roof of the building features a Chinese Chippendale trellis rail similar to those used by Thomas Jefferson at Monticello and at the University of Virginia.

THE REFECTORY AND CHAPEL AT
WESTERN LUNATIC ASYLUM. Behind
the main building is a stunning refectory
and chapel building, built from 1851
to 1854 and designed by Thomas
Blackburn. The chapel is a broad,
elliptical vault with Gothic windows and
original pews.

THE ERBEN PIPE ORGAN AT WESTERN
LUNATIC ASYLUM. Philanthropist
William Wilson Corcoran, secretary of
the interior and founder of the Corcoran
Gallery of Art in Washington, D.C.,
donated this rare Erben pipe organ to the
hospital during the late 19th century. It
is still located in the chapel. (Courtesy of
Historic Staunton Foundation.)

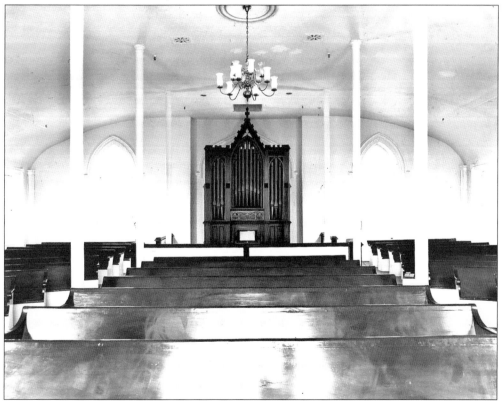

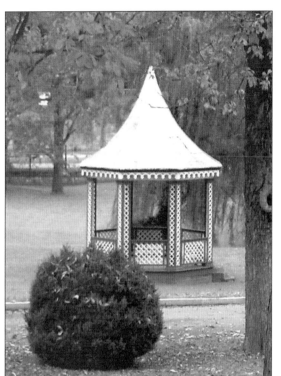

THE GAZEBO AT WESTERN LUNATIC ASYLUM. The complex of extraordinary buildings at the asylum was constructed along the side of a gently sloping hillside that is accessible through an enchanting park with a Victorian gazebo, benches, cast iron–tiered fountains, and a winding stream lined with willows. A cast iron fence, manufactured in Staunton and possibly designed by Blackburn, was installed during the mid-19th century to discourage local picnickers.

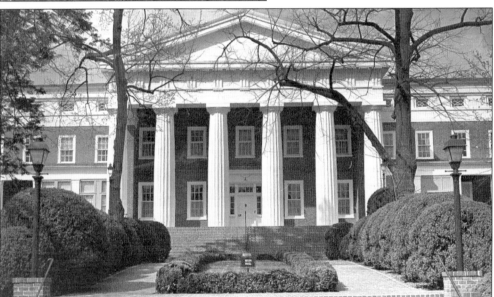

VIRGINIA SCHOOL FOR THE DEAF AND BLIND (VSDB). In 1839, while Robert Cary Long Jr. was designing the two major buildings at Western Lunatic Asylum, he also began work on this project. It took many years before the Virginia School for the Deaf and Blind was completed because of frequent budget shortfalls, which caused construction to periodically cease. This was the first time that schools for the deaf and blind would be combined under one roof. Construction was finally completed in 1846 after Thomas Blackburn was hired to get the project back on track.

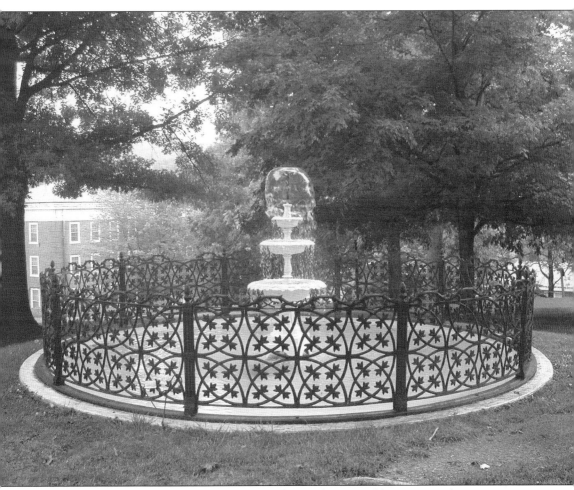

VIRGINIA SCHOOL FOR THE DEAF AND BLIND (VSDB). Pictured here is one of two cast iron fountains at the Virginia School for the Deaf and Blind.

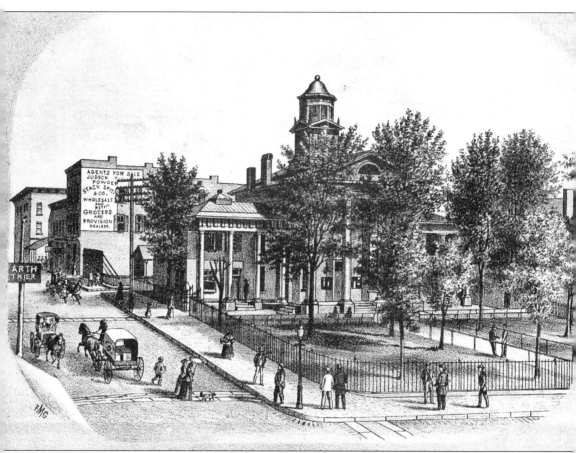

AUGUSTA COUNTY COURTHOUSE. Built in 1835 and 1836, this classical-style courthouse was designed by Thomas Blackburn, who would later move to Staunton for the remainder of his career to work on other projects at the Western Lunatic Asylum, Virginia School for the Deaf and Blind, and the Lutheran church, among others. This courthouse was enlarged and remodeled beyond recognition by T.J. Collins in 1901. (Courtesy of the Hamrick Collection.)

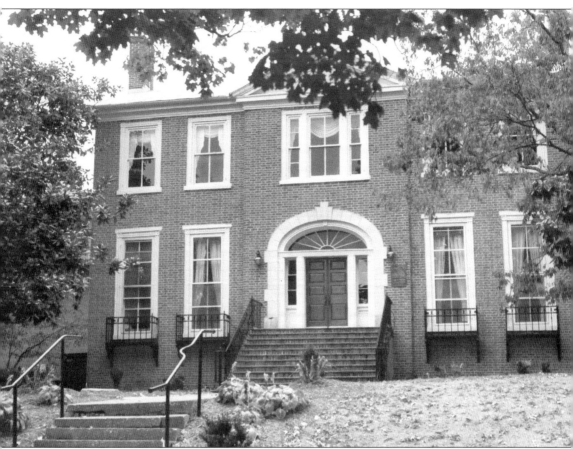

KALORAMA. This structure was constructed *c.* 1810 on the site of the manor house of William Beverly, the owner of the land that would later become Staunton. In 1830, the house became a school for girls , which later became The Virginia Female Institute, now known as Stuart Hall School. From the 1930s into the 1990s, the house served as the Staunton Public Library.

AUGUSTA FEMALE SEMINARY. Now Mary Baldwin College, it was established in 1842 by the Presbyterian Church in the Greek revival style, which was favored by most Staunton schools of the era. It is believed that the two wings flanking the central Doric portico were originally one story but were enlarged to their present form shortly after being built. To the right is the original First Presbyterian Church building, where Woodrow Wilson's father was the minister.

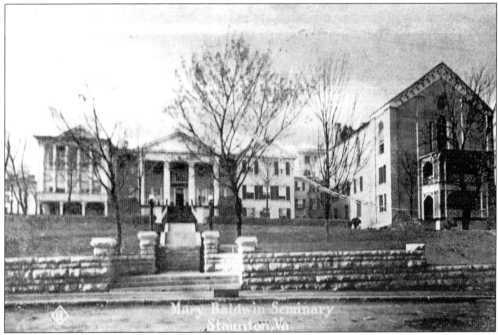

MARY BALDWIN SEMINARY. In this early 20th century view of Mary Baldwin Seminary (now Mary Baldwin College), the old First Presbyterian Church building has been modified with an additional floor and entirely new façade. After suffering structural problems caused by its many embellishments, the building was demolished in the 1960s.

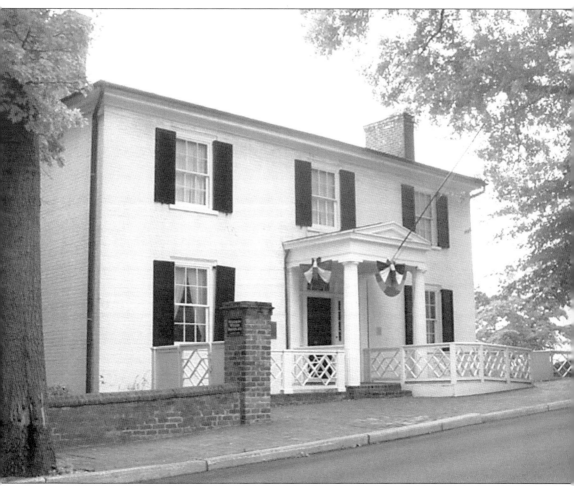

THE PRESBYTERIAN MANSE. Built as the Presbyterian Manse in 1846, this Greek revival–style house is best known today as the birthplace of President Woodrow Wilson, born December 28, 1856. The First Presbyterian Church was affluent, as demonstrated by the construction of this impressive house along a steep hillside overlooking the town. The house resembles some other houses that were built in Staunton around the same time and may have been designed by the same architect, Thomas Blackburn. This house was not originally painted white, so it would have looked even more like houses such as the Evans House, which stood north of the center of town.

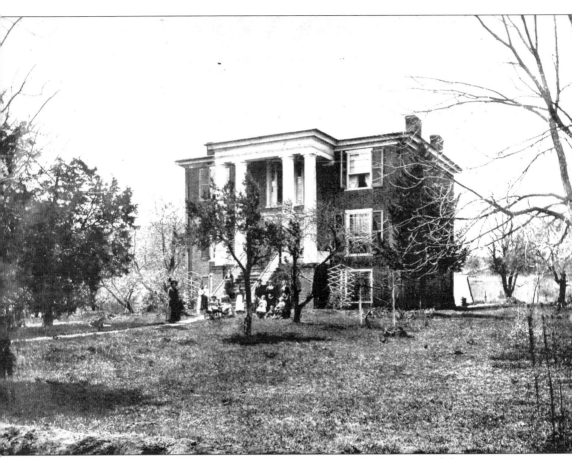

THE EVANS HOUSE. This imposing Greek revival–style house stood between Augusta Street and what is now Lewis Street, just south of Churchville Avenue. It was one of two nearly identical houses in this area of town; it is very similar in design to the Presbyterian Manse and was probably built around the same time. This photograph was taken during the 1880s, and the house was demolished sometime during the early 20th century. (Courtesy of the Hamrick Collection.)

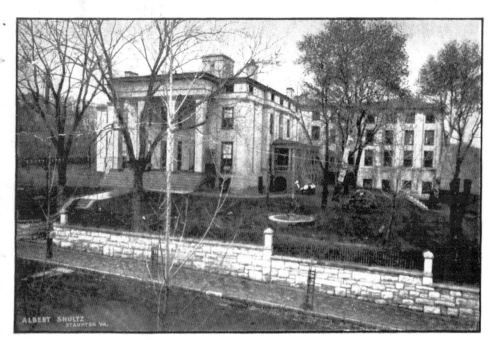

VIRGINIA FEMALE INSTITUTE, STAUNTON, VA.

From Blanche 27 – 05.

VIRGINIA FEMALE INSTITUTE (STUART HALL). It was founded in 1843, and Old Main was constructed in 1846 in the Greek revival style by Edwin Taylor. The massive portico with its Doric piers creates a beautiful vista because of the dramatic placement of this building at the northern terminus of Washington Street. For the last two decades of the 19th century, the widow of Confederate general J.E.B. Stuart served as headmistress of the school, which was renamed in her honor.

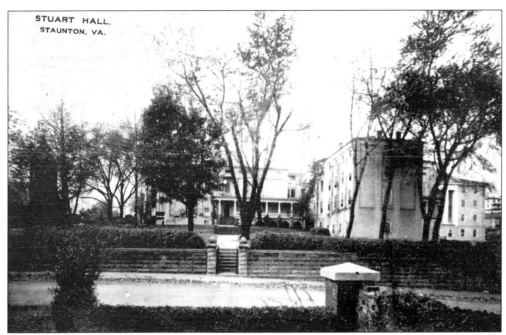

Virginia Female Institute (Stuart Hall). This unusual view of the school from the east side of the building was taken during the 1890s.

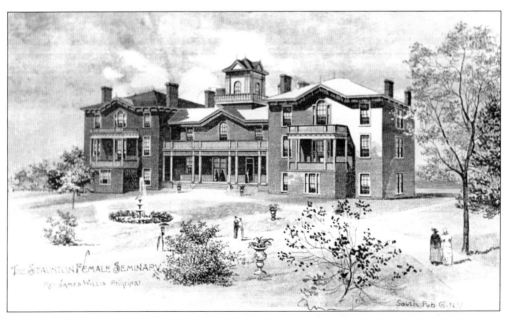

The Staunton Female Seminary. The Italianate revival–style Staunton Female Seminary stood on what is now the 200 block of South Fayette Street, and the two wings of the former school survive today as private homes. The school was associated with the Lutheran church.

Four

ARRIVAL OF
THE RAILROAD

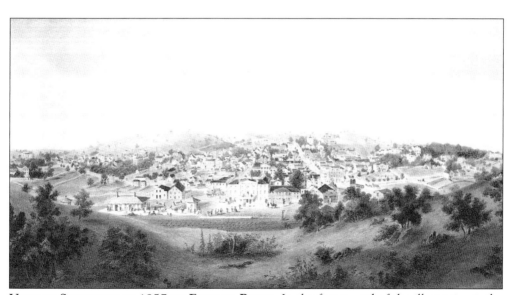

VIEW OF STAUNTON IN 1857 BY EDWARD BEYER. In the foreground of the illustration is the railroad station that was later burned by General Hunter's troops in 1864. To the right is The American Hotel, which survives, along with a quite a few of the other buildings shown.

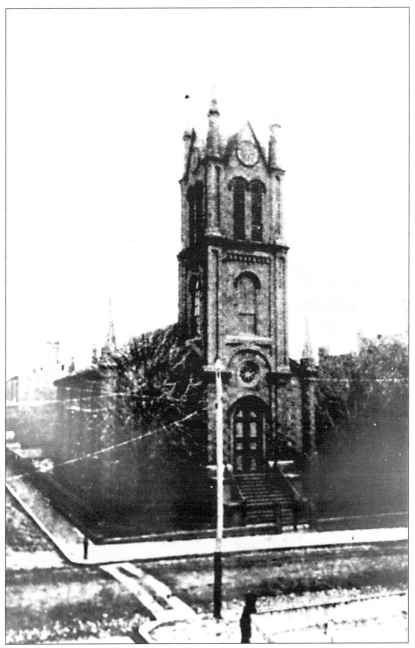

THE LUTHERAN CHURCH. The early 1850s were prosperous years in Staunton because of the arrival of the Virginia Central Railroad, and as a result, some remarkable new buildings were constructed here. Designed by Staunton architect Thomas Blackburn, this church was built in the early 1850s at the intersection of Central Avenue and Beverley Street. It is one of the earliest Gothic revival–style buildings in the city, and its tower housed the first official town clock. When the property was sold for the new YMCA in 1890, it was stipulated that the replacement building had to incorporate a new town clock as part of the design. Several Staunton churches held services in this building until the congregations were able to build their own sanctuaries. (Courtesy of the Hamrick Collection.)

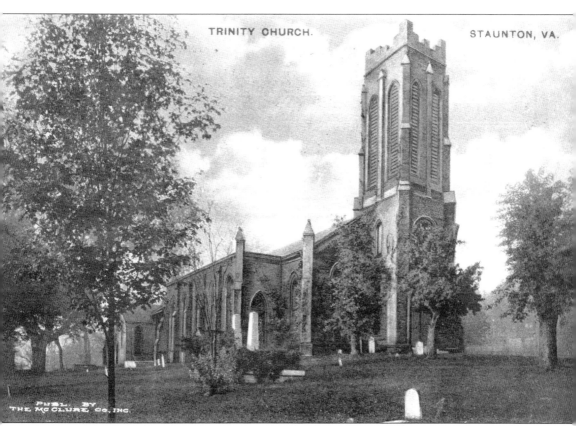

TRINITY EPISCOPAL CHURCH. An early example of the Gothic revival style in the valley, the present Trinity Episcopal Church was built in 1855 and is believed to have been designed by architect J.W. Jones. The simple design with its buttressed tower must have looked very solemn in comparison to the less restrained Gothic revival–style Lutheran church built a block away at about the same time. Trinity Church has been enlarged several times, and each development has disturbed graves in the surrounding graveyard, the oldest cemetery in Staunton. This church building originally featured simple leaded-glass windows with diamond shaped panes surrounded by brightly colored glass panels with a simple vine pattern. Several original windows survive; however, they are somewhat overshadowed by a magnificent collection of later windows created by leading glass artisans such as Tiffany Studios installed between the 1870s and early 20th century. The original church also had some type of decorative painting on the ceiling, which is described in newspaper accounts from the mid-1850s but has long since disappeared. This view *c.* 1912 shows the church as it appeared then with several additions to the 1850s structure.

SKINNER HOUSE. This simple but charming Italianate-style house set on a hillside with mature trees was built in 1856 by naval officer Charles W. Skinner, whose daughter was a student at the Virginia School for the Deaf and Blind. The delicate wood porch mimics cast

iron. The house later became the infirmary for Staunton Military Academy and is now owned by Mary Baldwin College.

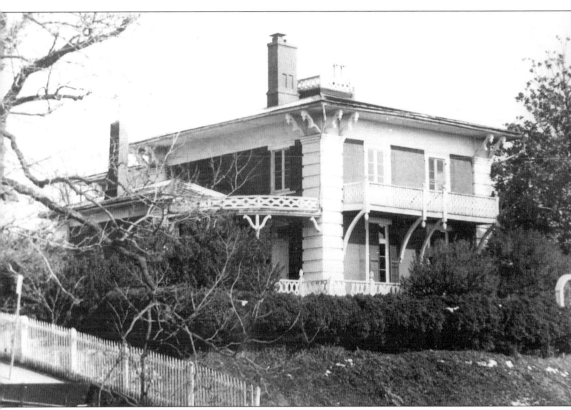

JOHN IMBODEN HOUSE. Prominent Staunton citizen John Imboden built a beautiful house with terraced gardens along the hillside overlooking the town in the 1850s. The Italianate mansion is said to have had a separate structure with the first bathtub in the city. The very interesting design featured a large overhanging cornice with clusters of support brackets around the corners rather than across the entire length of the cornice. During the Civil War, Imboden became a Confederate general and moved to Augusta County, selling this house to the Bickle family, who maintained ownership until the late 1960s when it was acquired by Mary Baldwin College. Unfortunately, the college demolished this extraordinary house to make room for a parking lot. (Courtesy of the Hamrick Collection.)

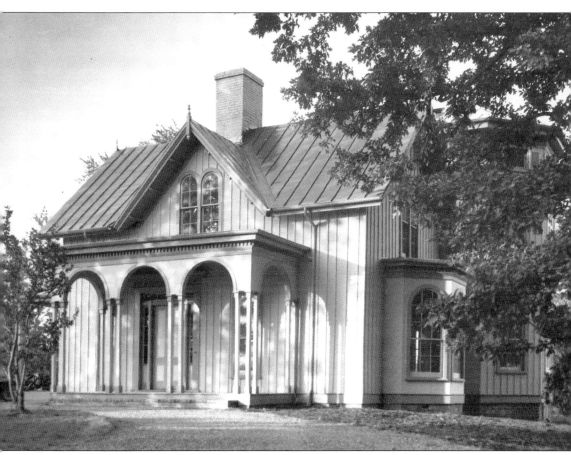

DR. BARNAS SEARS HOUSE. This home was built in 1866 on top of a steep hill (now known as Sears Hill) overlooking the center of town. Dr. Robert Madison, physician for the Virginia Military Institute cadets in the battle of New Market, built the house and a large three-story polygonal wing to accommodate his library. Simple board-and-batten bracketed cottages such as this were promoted by noted architect Andrew Jackson Downing as ideal for middle-class Americans.

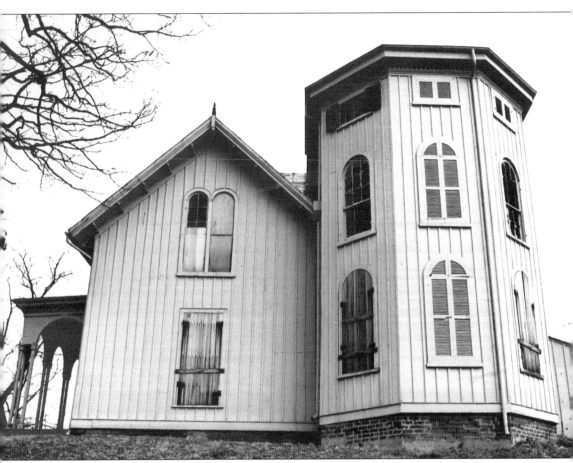

LIBRARY WING OF THE DR. BARNAS SEARS HOUSE. The name for this house comes from the second occupant, Dr. Barnas Sears, an educator who was chosen by Boston philanthropist George Peabody to administer the Peabody Educational Fund, which established free schools in the South following the Civil War.

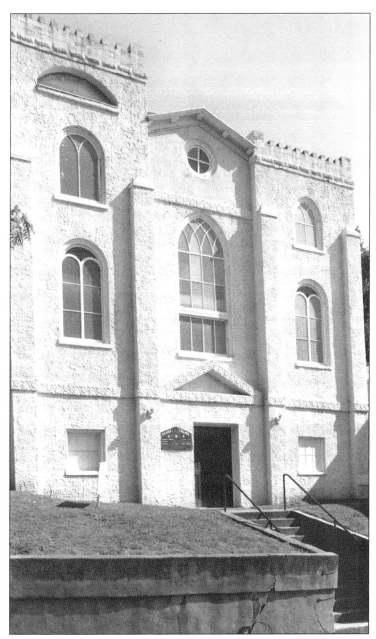

ALLEN CHAPEL. Shortly after the conclusion of the Civil War in 1865, the African Methodist Episcopal Church was established in Staunton as the first African-American congregation in Virginia west of the Blue Ridge Mountains. The congregation first held services in the Lutheran church then located on what is now Beverley Street at Central Avenue, the current site of the Town Clock Building. Eventually, enough funds were raised to build Allen Chapel in 1868, which was expanded in 1924. The chapel was named in honor of Richard Allen, a former slave who gained his freedom and became an influential religious leader in Pennsylvania, a founder of the African Methodist Episcopal Church in the U.S., and its first bishop. Although the church building survives at 921 West Beverley Street, the congregation has since moved to newer quarters elsewhere in the city.

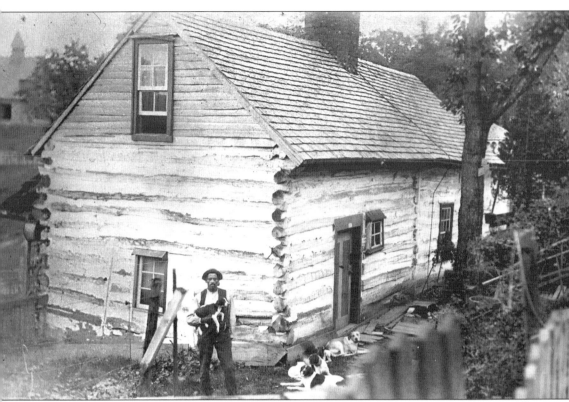

CABELL HOUSE. Although Staunton was once a town comprised almost entirely of buildings constructed out of logs, the Cabell House at 654 East Beverley Street is the lone surviving exposed log structure. Several buildings throughout the city are constructed of logs, but they are covered with wood siding, which was often done at the time of construction. This house was built around 1869 by Edmund Cabell, who was described prior to the Civil War as a "Freeman of colour." He purchased the lot on June 16, 1866, and is believed to have built the original two-room house using recycled logs from demolished buildings. The house suffered a fire in a two-room addition to the rear in 1920, but the original house was spared. It remained in the Cabell family for more than 120 years, but in 1987, the house was purchased by the Historic Staunton Foundation and resold with restrictive covenants for renovation and preservation. (Courtesy of the Hamrick Collection.)

Five

THE BOOM YEARS

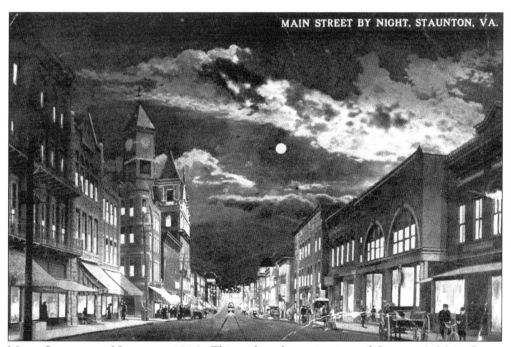

MAIN STREET BY NIGHT C. 1906. This rather dramatic view of Staunton's Main Street (Beverley Street) uses a bit of artistic license such as making a major "widening" of the width of the street. Horse-drawn carriages can be seen, as well as a trolley car in the distance. The building on the right with the large arches was later remodeled by what would become Leggett's Department Store and now serves as the present city hall.

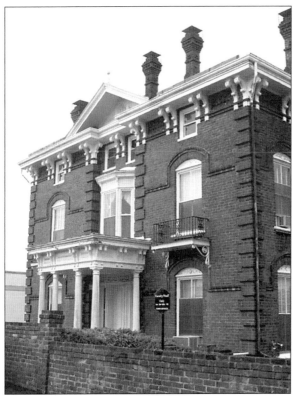

ROSE TERRACE. This elegant Italianate house perched near the top of Market Street was built for the Erwin family *c.* 1875 and has been used by Mary Baldwin College for many years. The house features beautiful details including fanciful chimneys, delicately carved wood detailing, and ornate brickwork.

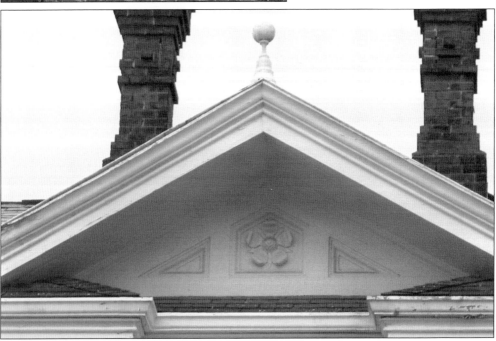

ROSE TERRACE DETAIL. The façade of Rose Terrace has some unusual features such as cast iron balconies, which are rare in Staunton, and a delicately carved rose motif in the pediment, which is most appropriate for a house of this name.

HISTORIC STAUNTON FOUNDATION BUILDING. This unusual building was built in 1876 over Lewis Creek, which flows underneath. The upper portions of the façade are made out of pressed and corrugated metal, a rare building material in Staunton.

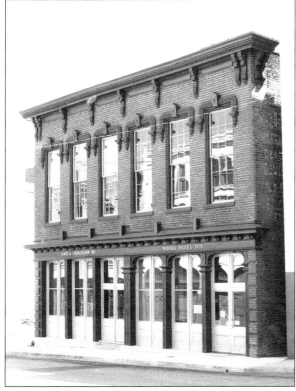

HOGE & HUTCHINSON WAREHOUSE. Built as the wholesale grocery house of Hoge & Hutchinson in 1881, this handsome Italianate-style building features cast iron and tin architectural detailing. The monumental windows on the upper level are an interesting feature. (Courtesy of the Hamrick Collection.)

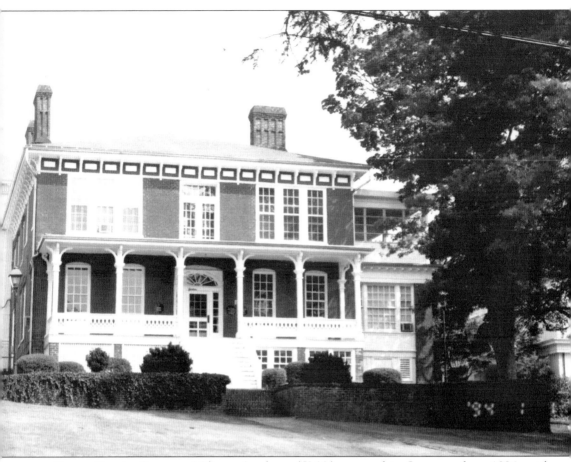

KABLE HOUSE. Staunton Military Academy (SMA) operated in Staunton from 1884 until 1976. SMA was started by Capt. William H. Kable in this magnificent Italianate-style house that had been built in 1873 by J.W. Alby. SMA actually had its beginnings in 1860 in what is now Charlestown, West Virginia, with the Charles Town Male Academy, also founded by Captain Kable. Unhappy that the state had split during the Civil War, he relocated the school to Staunton.

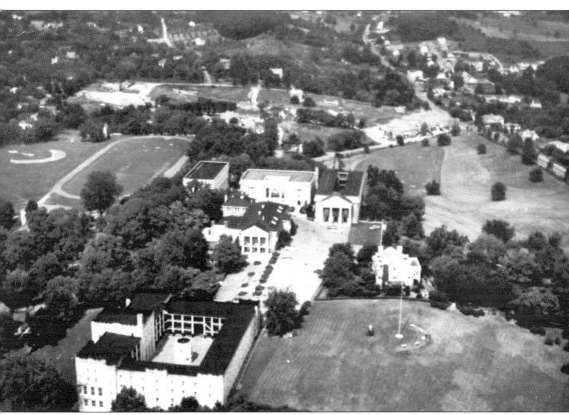

STAUNTON MILITARY ACADEMY. The SMA campus occupied the top of the hill behind Mary Baldwin College, a site offering great views of the valley and mountain ranges to the east and west. The large building in the foreground, the barracks, was demolished in 1982.

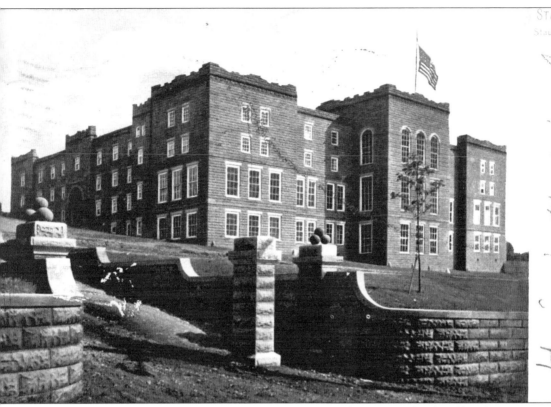

THE BARRACKS AT STAUNTON MILITARY ACADEMY. The campus for the all-male Staunton Military Academy was very close to that of the all-female Mary Baldwin College, leading to some interesting relationships between the schools. One of SMA's best known graduates was Barry Goldwater, former U.S. senator and 1964 candidate for president.

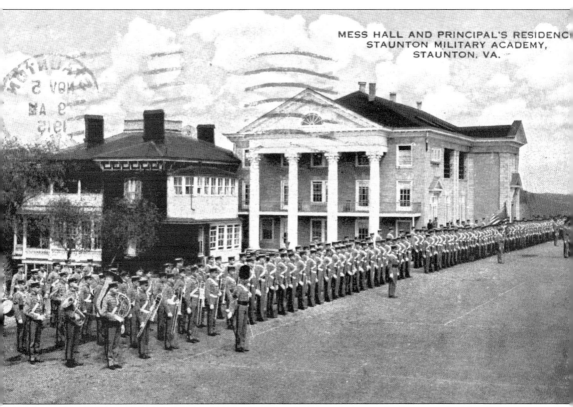

MESS HALL AND PRINCIPAL'S RESIDENC
STAUNTON MILITARY ACADEMY,
STAUNTON, VA.

THE SMA MESS HALL. Built in 1912 and 1913, this was the site of a banquet held in honor of President-elect Woodrow Wilson during his visit in late December 1912. The mess hall is a huge room supported by slender cast iron columns. The building is used today by Mary Baldwin College.

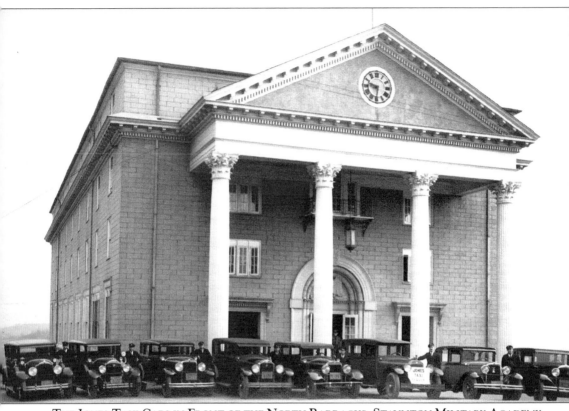

THE JONES TAXI CABS IN FRONT OF THE NORTH BARRACKS, STAUNTON MILITARY ACADEMY. Following the closure of SMA, the campus was acquired by adjoining Mary Baldwin College, which demolished a number of the buildings including this one, the north barracks, in 1982. This photo shows cabs operated by the Jones Taxi Service posed in front of the building during the 1920s. (Courtesy of the Hamrick Collection.)

JAMES FOSTER HOUSE. Many houses built shortly after the Civil War in Staunton included a combination of architectural styles, often Greek revival and Italianate, such as this one on North New Street. This particular example was constructed in 1868 by carpenter James Foster. William Haines was born in this house on January 1, 1900. Haines, who starred in 50 films and was first MGM star to speak on film, has a star on the Hollywood Walk of Fame. After becoming the leading male film star in the world in 1930, he launched a new career as one of the leading interior designers in the nation.

ITALIANATE BUILDINGS ON FREDERICK STREET. Built during the 1870s, these substantial Italianate-style buildings housed businesses on the street level with the business owners living upstairs, a common practice during the era. The building to the right was later used by one of Staunton's African American–owned banks, the People's Dime Savings Bank, from 1929 into the early 1930s.

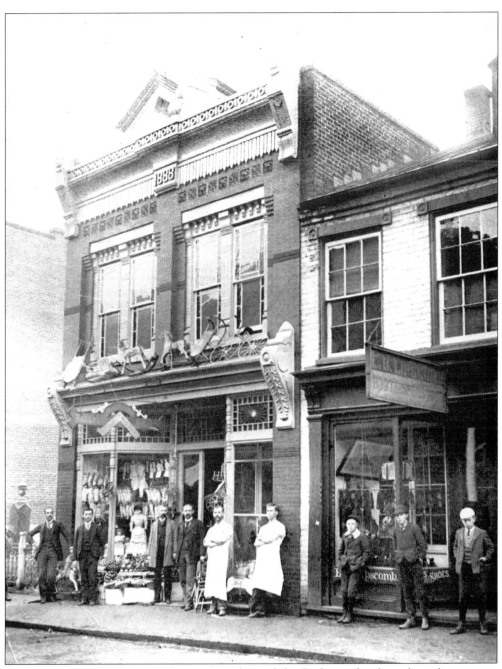

BARKMAN'S CONFECTIONARY. Various members of the Barkman family and employees pose in front of their store built in 1888 at what is now 12 East Beverley Street. The business also sold toys, some of which are displayed in front of the second story windows, including sleds, rocking horses, and a bicycle. Additional toys including dolls can be seen in the display window and along the sidewalk. The building to the right, built c. 1815, was a boot and shoe store at the time of this photograph. Some Barkman family members were actively involved in the Stonewall Brigade Band. (Courtesy of the Hamrick Collection.)

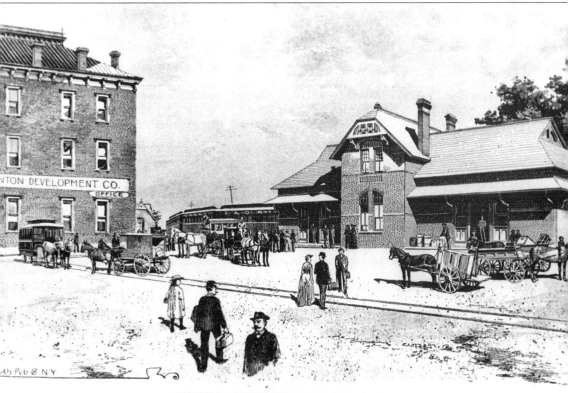

CHESAPEAKE AND OHIO RAILWAY PASSENGER DEPOT.

C & O Railroad Depot and American Hotel Building. There have been three railroad stations on this site since 1854, when the Virginia Central Railroad built a small depot, which was burned by General Hunter's troops in 1864. The second railroad station is shown in this illustration from the early 1890s. The building identified as the Staunton Development Co. was the former American Hotel, a large Greek revival–style building that has recently undergone a major renovation. It was built in 1854 by the railroad and was once one of the finest hotels in the city. The reconstruction era governor of Virginia, Francis Pierpont, was a guest here in 1866, and former Confederate general P.G.T. Beauregard stayed here in 1874. In June 1874, President and Mrs. Ulysses S. Grant were serenaded by Staunton's Stonewall Brigade Band from the front portico of this hotel when their train passed through Staunton. (Courtesy of the Hamrick Collection.)

BUILDINGS ON BEVERLEY STREET. These two buildings were both built during the 1830s in a very simple classical form but were updated during the 1880s with Mansard roofs, which are characteristic of the French Second Empire style of architecture. Inspired by Parisian architecture, the buildings bring a little bit of Paris to downtown Staunton.

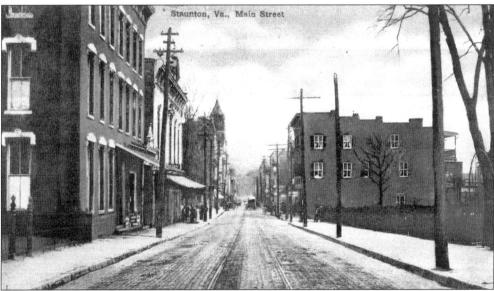

BEVERLEY STREET IN FRONT OF TRINITY EPISCOPAL CHURCH. During the late 19th century, a few commercial structures were built along Beverley, or Main Street as it was often called, west of the intersection with Lewis Street. In this image from the 1890s, the clear area to the right is the graveyard in front of Trinity Episcopal Church. The iron fence on the far left is in front of the Stonewall Jackson School. The building on the left was constructed during the late 1880s, and materials were recycled many years later to construct the headquarters for the John D. Eiland Company in Verona, just north of Staunton. Note the trolley tracks down the middle of the street and the top of the clock tower building in the distance.

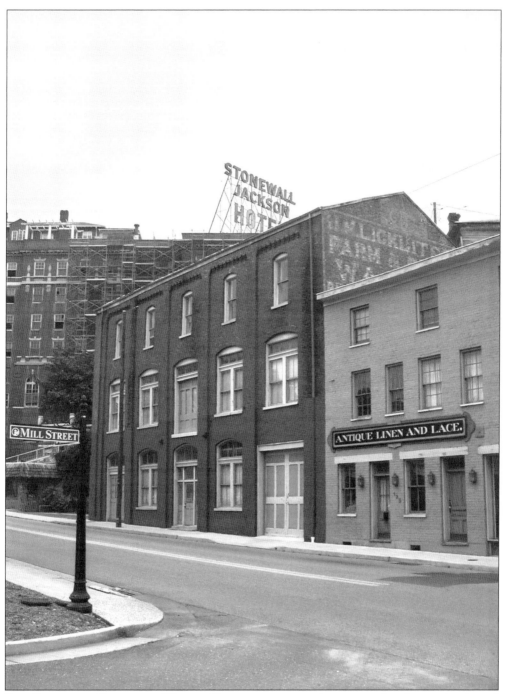

The Lickliter Carriage Works. Staunton was a major center for the production of horse-drawn carriages, and this is one of the few surviving buildings that served this purpose. The ghost of the old Lickliter Carriage Works sign can still be seen on the eastern end of the building. Notice the second story openings that would allow carriages to be hoisted up to the second level using pulleys.

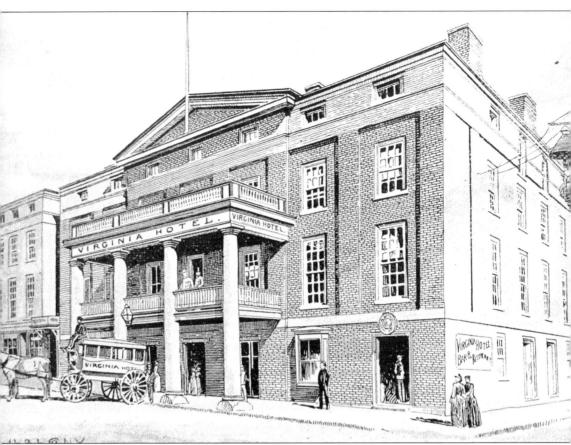

THE VIRGINIA HOTEL. Here, Union general David Hunter made his headquarters and met with Staunton mayor Nicholas K. Trout, members of the town council, and other prominent citizens. Hunter agreed to spare much of the town with the exception of industries and supplies useful to the Confederates. The hotel underwent many changes, including the one illustrated here around the turn of the century when a Mansard roof was added and the building was renamed New Virginia Hotel. The old building was finally demolished in October 1929 to make way for a new addition to the Stonewall Jackson Hotel that would have included some parking for the new hotelier. The stock market crash that month kept the site from being developed until 2001, when the New Street parking garage was finally constructed on the site of the hotel and several adjoining lots. Interestingly, the parking garage will be supplying spaces for guests to the renovated Stonewall Jackson Hotel. (Courtesy of the Hamrick Collection.)

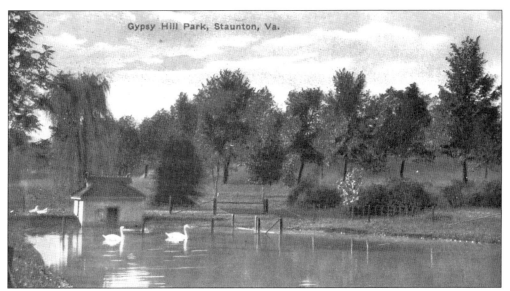

Gypsy Hill Park, Staunton, Va.

GYPSY HILL PARK. In 1876, the city acquired 30 acres from the Donaghe estate in an effort to protect the water supply. The city added gradually to this acreage over the years, and through the lobbying of Capt. William Purviance Tams, it was decided in 1889 to develop the property for a public park. Captain Tams supervised much of the work needed to landscape the property. Most of the trees were planted by Staunton children on Arbor Day in 1889 and 1890 while the Stonewall Brigade Band performed. Several pavilions and a pump house were built, along with a bandstand from which the Stonewall Brigade Band performed concerts during the summer months, a tradition that continues to this day. This c. 1912 view of Gypsy Hill Park shows a pond with swans and a small structure that may have been a winter home for ducks and geese.

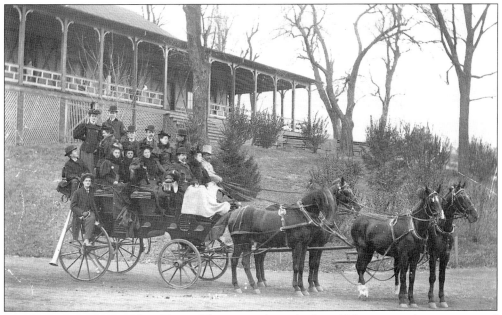

AN OUTING IN GYPSY HILL PARK. This image from the late 19th century shows a group of people arriving at Gypsy Hill Park by carriage. The pavilion in the rear with a porch that surrounds the building survives to this day.

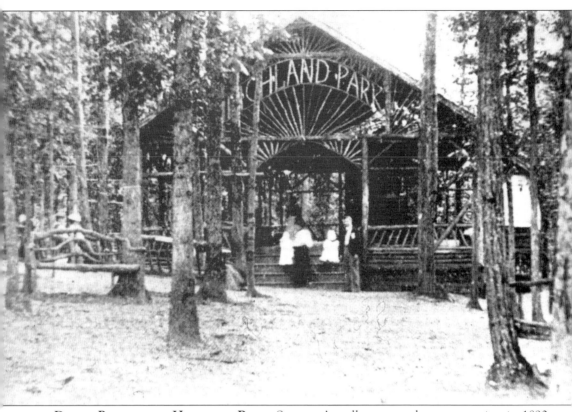

DANCE PAVILION AT HIGHLAND PARK. Staunton's trolley system began operating in 1890 with a fleet of 12 mule-drawn cars (converted to electric power in 1896) that transported people from the center of town to the outskirts of the city. As in other communities across the country, the trolley lines helped in the development of new suburban neighborhoods, and the streetcar operators offered recreational activities that often took the form of amusement parks at the end of the trolley line. Such was the case in Staunton; there, the Staunton Light and Power Company operated Highland Park, which included an amusement area with a dance pavilion.

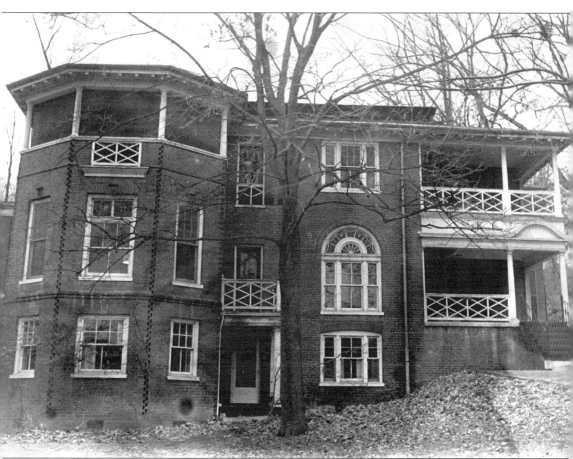

THE OAKS. This was the home of Jedediah Hotchkiss, a native of New York who served as the chief topographical engineer and mapmaker for Stonewall Jackson. His maps, which are credited as being key to Jackson's many successes in the Valley campaign, are today housed in the Library of Congress. Hotchkiss, who settled in Augusta County during the 1840s, administered two boys academies until the Civil War. He later moved to Staunton, and following the war, he made a fortune in land development and in the mining of minerals. In 1888, he added to the front of his home known as the Oaks. An iron fence in front of the house features acorns, and the oak leaf and acorn motif is used inside the house in a large arched stained glass window. The Queen Anne–style addition, with its irregular façade, was designed by the prominent firm of Winslow and Wetherall of Boston. (Courtesy of Historic Staunton Foundation.)

DUNSMORE BUSINESS SCHOOL. Founded in 1872 and in operation for many years, Dunsmore Business School had an excellent reputation as a preparatory school for students interested in banking, bookkeeping, and accounting. T.J. Collins designed a building for the school along West Beverley Street that was easily assessable to the students by trolley.

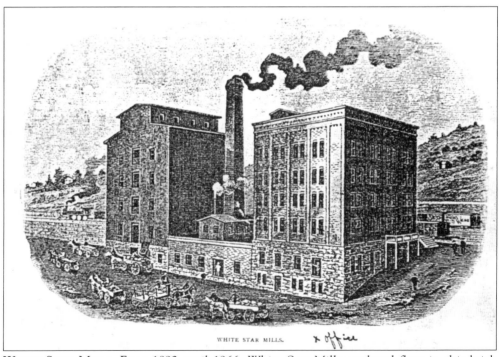

WHITE STAR MILLS. From 1892 until 1966, White Star Mills produced flour in this brick structure adjoining the railroad tracks. It was built on a large limestone foundation at the foot of New Street, down the hill from the home of Michael Kivlighan, one of the mill's owners.

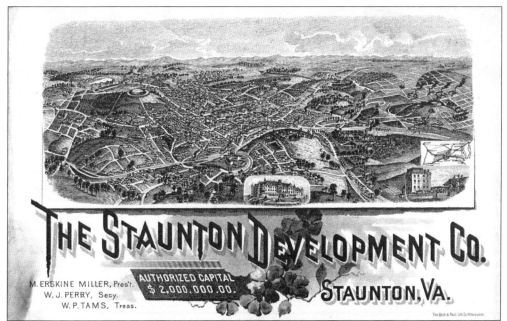

THE STAUNTON DEVELOPMENT COMPANY. The real estate boom of the late 19th century led to elaborate plans by the Staunton Development Company to expand the city of Staunton to the north, east, and west. The company went bankrupt, however, before the expansion plans could be executed. This venture benefited Staunton, though, in that it lured a young architect, T.J. Collins, and he remained to embellish the town with many architectural treasures.

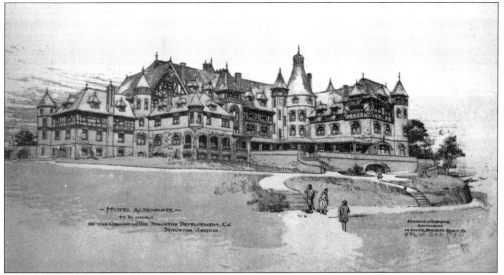

HOTEL ALTEMONTE. This elaborate hotel was planned by the Staunton Development Company but was never constructed. This confection was designed by the Philadelphia firm of Yarnall and Goforth using a mixture of picturesque architectural styles, primarily French, and featuring towers and turrets that one might expect to find on a château. A much smaller version of the most prominent tower planned for the hotel can be found at Staunton's Oakdene, designed by the same firm and constructed a couple of years after the hotel design was first published.

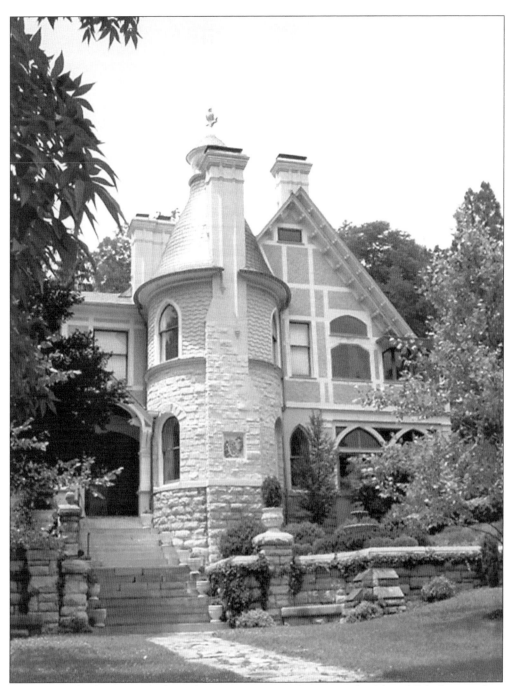

OAKDENE. This house was built in the Queen Anne style in 1893 for Edward Echols, president of the National Valley Bank and lieutenant governor of Virginia (1898–1902). It was designed by the prominent Philadelphia firm of Yarnell and Goforth, which had designed the Hotel Altemonte that was to have been built not far from this site. The asymmetrical composition with its irregular roofline, a wide variety of sizes and shapes of windows, and contrasting building materials are all characteristics of the style. The house remained home to Echols family members for a century.

OAKDENE IN DETAIL. The most fanciful element to the design of Oakdene is the owl perched atop the tower; its eyes can be lighted at night. This is most certainly one of Staunton's most precious architectural features.

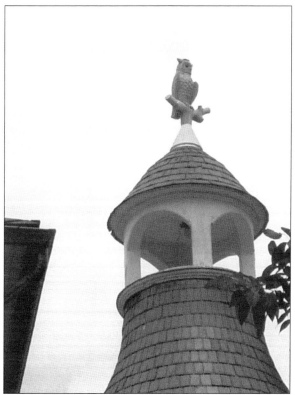

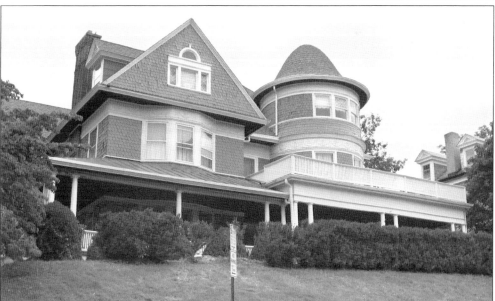

THE CATLETT HOUSE. Built *c.* 1896, this is one of a couple of fine examples of Queen Anne–style mansions incorporating elements of the shingle style of architecture in Staunton. The asymmetrical technique features a variety of building materials including shingles with varying textures and shapes and large porches. This example overlooks the Greek revival–style Presbyterian Manse across the street.

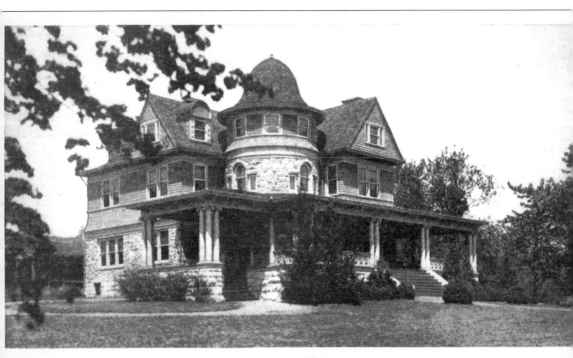

BREEZY HILL INN AND TEA HOUSE, STAUNTON, VIRGINIA; altitude 1600 feet. A progres City in the famous Shenandoah Valley, the birthplace of Woodrow Wilson, on State highway lea north to Harrisonburg and Winchester, south to Lexington and Natural Bridge, west to Hot, Warm White Sulphur Springs, and east to Charlottesville. Light airy rooms, large grounds, parking space, licious meals. Telephone local and long distance 750, Staunton, Va.

BREEZY HILL. This mansion, built about the same time as the Catlett House, incorporates elements of the same styles in different manners. This 30-room house features a wide variety of building materials—including stone, wood, and slate—for texture and variety. There are also windows of every conceivable size and shape and a large wrap-around porch with a port-cochère. This example was constructed in 1896 for Thomas B. Grasty, and the design has been attributed to Staunton architect T.J. Collins.

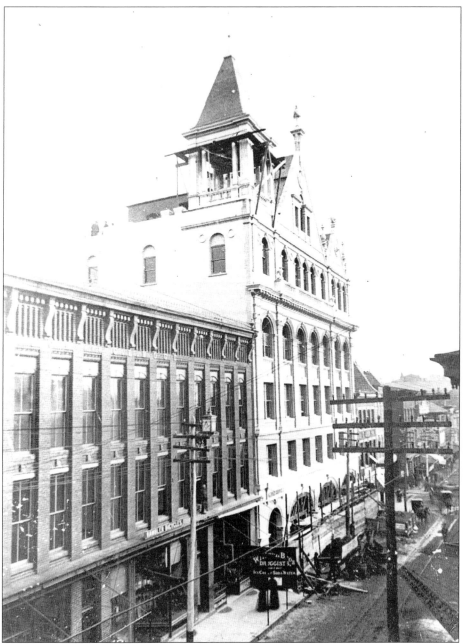

THE MASONIC TEMPLE. Staunton's Masonic temple was built 1894–1896 according to the designs of Chicago architect Isaac E.A. Rose, who also designed buildings at Virginia Military Institute in nearby Lexington. By far the largest and tallest building in the city when it was constructed, it was the first building that was totally electrified and to have an elevator. Built of cream colored brick, with cream terra cotta details that include urns, a giant lion's head, Masonic symbols, and balustrades, the building housed shops, offices, a law library, and Masonic lodge. The building to the left is the Gooch and Hoge building; with a strong emphasis on verticality, it was stylistically influenced by constructions in Chicago during the era. (Courtesy of the Hamrick Collection.)

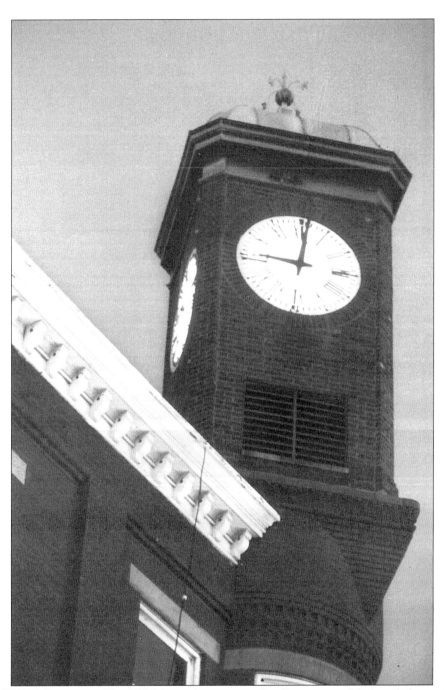

THE **YMCA** BUILDING. The YMCA was first organized in Staunton in 1874, and along with it came the town's first public library. The first building specifically for use by the Y in Staunton was designed by S.W. Fouke of New Castle, Pennsylvania, and was occupied in November 1889. Built on the site of the old Lutheran church, it housed the official town clock, which is maintained to this day by the City. A projecting four-sided tower allowed for four lighted dials, which offered the time in varying directions, including a good distance down Main Street. Those too far away to see the dials of the clocks could hear the 24-hour chimes.

THE CLOCK TOWER. The tower of the former YMCA building was remodeled around 1930 with a smaller clock tower, with lighted dials and chimes that still ring loud and clear throughout the city. Following its use as a YMCA, the building became Bryan's Department Store and then a Woolworth's; it presently houses apartments on the upper floors and a restaurant and convenience store on the street level. The building is still considered one of Staunton's best-known landmarks.

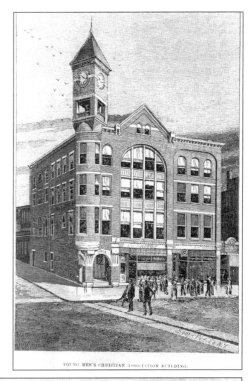

YOUNG MEN'S CHRISTIAN ASSOCIATION BUILDING.

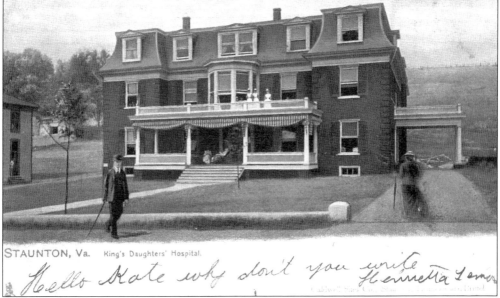

STAUNTON, Va. King's Daughters' Hospital.

KING'S DAUGHTERS HOSPITAL. In 1905, Staunton opened a new hospital in the former William Haines family home on East Frederick Street. The house had been built in the 1890s and featured a stylish Second Empire Mansard roof. Staunton did not have a public hospital until 1890, when a tragedy convinced townspeople that one was needed. A passenger train arriving in Staunton in April of that year had brake problems that caused the last car to derail; one passenger was killed, and 15 others were cared for in private homes. This led to the founding of King's Daughters Hospital six years later.

69

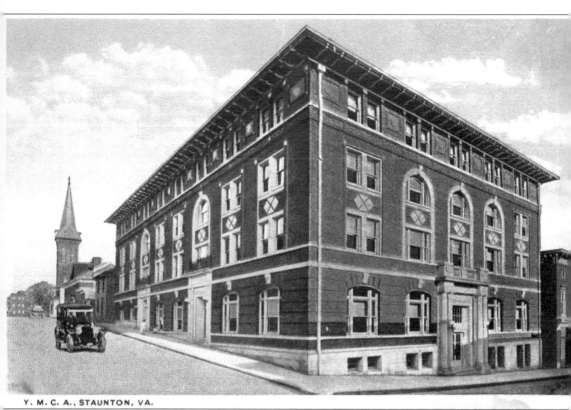

Y. M. C. A., STAUNTON, VA.

A NEW YMCA BUILDING. In 1916, the YMCA moved into new quarters, a handsome Italian Renaissance revival–style structure funded by the estate of Cyrus McCormick, the inventor of the reaper; his farm was located a short distance south of Staunton. The public library continued to operate here until it moved to Market Street in 1940.

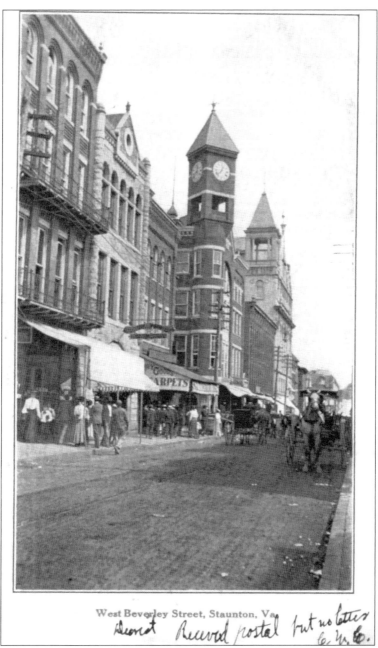

West Beverley Street, Staunton, Va.

REBUILDING THE BUSINESS DISTRICT. Much of downtown Staunton's business district was either rebuilt or remodeled during the late 19th century. This scene from 1906 shows from left to right, part of the Hoover House Hotel, a four-story building with iron balconies on the second and third floor levels, as well as the showroom for Staunton's Putnum Organ Works, a Romanesque revival–style structure built by the Valz family in 1894 with an elaborate carved stone façade including a large archway on the street level. The Putnam Organ Works was established in 1894 in Brattleboro, Vermont, by W.W. Putnam. Seeing potential for portable organs, he moved to Staunton in 1896 where he produced church and parlor organs in large quantities at a factory east of downtown, and then sold them in this Beverley Street showroom.

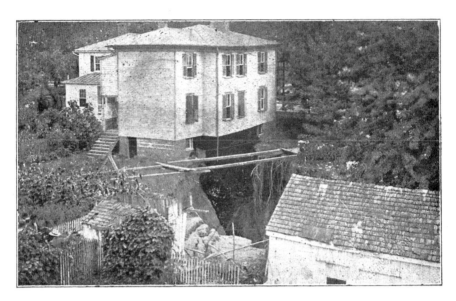

STAUNTON, VA., North side of Todd house, showing Cave-in above the Cave.

THE GREAT 1910 SINKHOLE. Staunton experienced an unexpected urban renewal project in 1910 with a cave-in that attracted national attention. A giant sink hole suddenly appeared and began swallowing houses. Enterprising citizens charged money for curious visitors to walk across planks to peer into the bottomless pit.

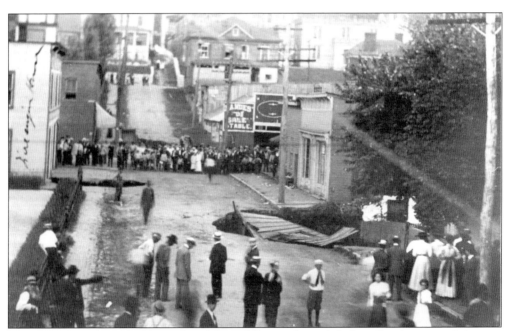

THE CAVE-INS. Some buildings that did not fall into the sink hole suffered structural damage and were subsequently demolished.

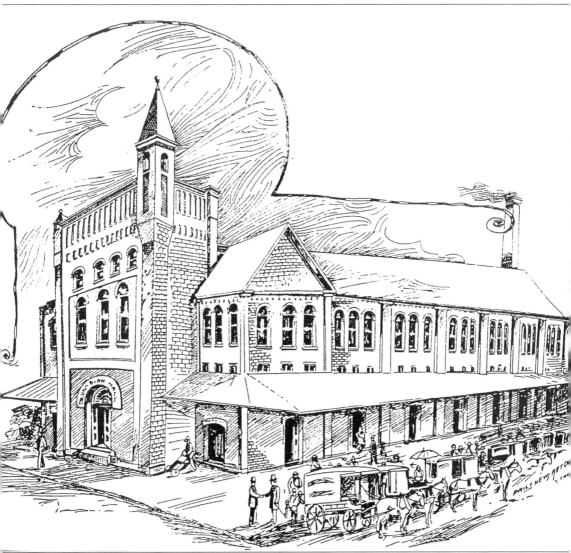

COLUMBIA HALL. One victim of the cave-ins of 1910 was Columbia Hall. Built by the City in 1896 as a combination Market and Convention Center, the building featured an indoor space with ceiling fans to keep the produce cool during warm weather. Local farmers also used an outdoor shed, which stretched across the side of the market. Upstairs, the space with seating for 1,500 hosted both the state Republican and Democratic Party conventions in 1896. The building stood at the intersection of Lewis and Baldwin Streets.

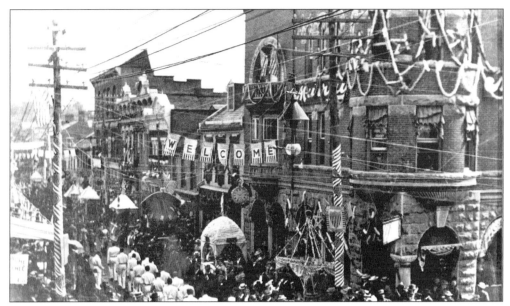

STREET CARNIVALS. Under the leadership of local cigar manufacturer Charles Haines, a series of popular street fairs and carnivals took place beginning around 1896 and continued into the early 20th century. For these Labor Day festivals, the streets were elaborately decorated with flags and bunting, and booths were set up along the street to sell various products. The building on the right is the Marquis building, a Romanesque revival–style building designed by T.J. Collins, who had his offices on the second floor. The elaborate rusticated stonework with large arched openings along the first floor is characteristic of the style, and in this case, it featured plate glass windows to fill the archways. The Marquis was built for the Marquis family, who made a fortune producing cut stonework, including tombstones. (Courtesy of the Hamrick Collection.)

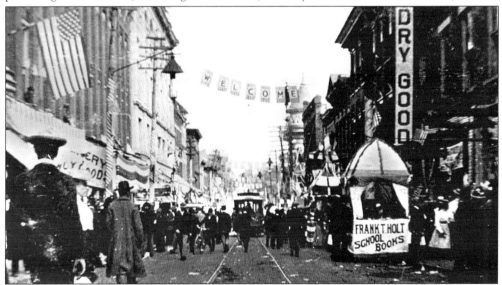

STREET CARNIVAL, BEVERLEY STREET. Looking east from Central Avenue, this shows a street carnival in the early 20th century. The Crowle building is to the right, and the building with the dry goods sign houses the Haines Cigar Factory on the second floor. The Gooch and Hoge building is on the left, followed by the Masonic Temple. (Courtesy of the Hamrick Collection.)

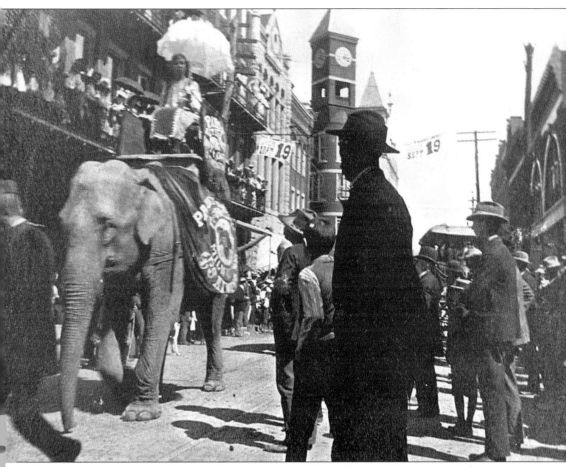

Elephant on Beverley Street. During the late 19th and early 20th centuries, the circus came often to Staunton. Arriving at the railroad station, the circus would put on a fee show near the station as a way of promotion, followed by a parade on Beverley Street that led the west of the city where it would set up the Big Top.

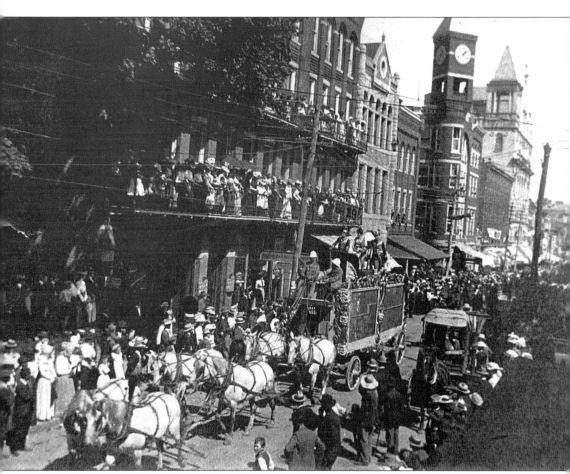

LIONS, TIGERS, AND BEARS, OH MY! This view shows a Wallace Circus parade on September 19, 1901, on Beverley Street between Lewis Street and Central Avenue. Six white horses are pulling a large animal cage, probably filled with tigers. Note the crowds not only on the streets but also on the balconies. (Courtesy of the Hamrick Collection.)

Six

T.J. Collins and Sons Rebuilding the City

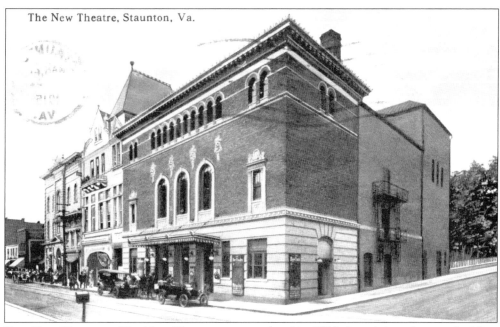

The New Theatre, Staunton, Va.

THE NEW THEATRE. The New Theatre was completed in 1913. It and the other two building shown in this image housed theatres at various time. To the immediate left of the New Theatre is the Old Fellows Hall, which was later known as the Arcadia Building. To its left is the Beverley Theatre, which is now the City Courts Building. While all of these building survive, each looks very different because of the major remodeling of each structure, and in the case of the New Theatre, a tragic fire in 1936 that removed the top floor and resulted in essentially a new theatre with a new name, Dixie.

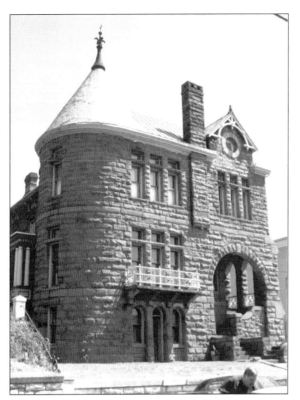

THE ARISTA HOGE HOUSE. In 1890, an architect named T.J. Collins from Washington, D.C., came to Staunton to work for the Staunton Development Company, which had elaborate plans for the expanding city. Shortly after his arrival, the company went bankrupt, and Collins was stranded. He set up a brief partnership with another architect and then set out on his own to start a highly successful career as Staunton's preeminent architect for the era. One of his early commissions was to design a new façade for the home of the city treasurer, Arista Hoge. Collins designed an elaborate Romanesque revival–style façade unlike any other house in the city; it has been dubbed "the castle" by locals.

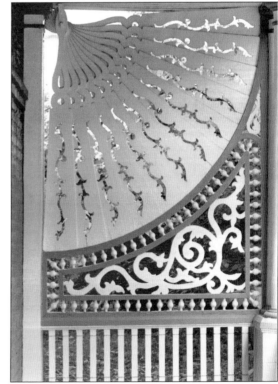

THE ARISTA HOGE HOUSE IN DETAIL. One interesting artistic touch is this fan motif used on one of the two massive side porches. (Courtesy of Historic Staunton Foundation.)

THORNROSE CEMETERY. T.J. Collins's work on Arista Hoge's house led to a much larger commission to design numerous structures for Thornrose Cemetery, which was undergoing a massive expansion and beautification program under Mr. Hoge's direction.

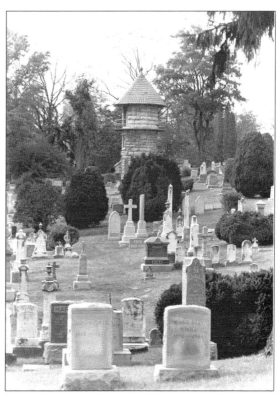

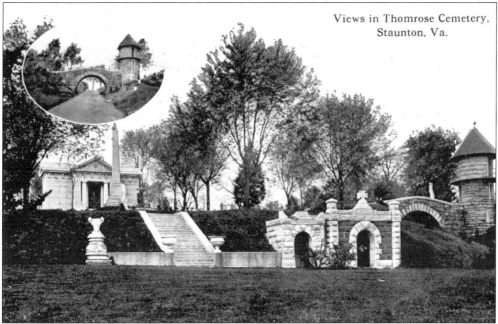

Views in Thomrose Cemetery, Staunton, Va.

THORNROSE CEMETERY MAUSOLEUMS AND STAIRCASE TO THE ECHOLS PLOT. T.J. Collins designed entrance gates, a pedestrian bridge, a mortuary chapel, a series of five mausoleums, and various other structures for the cemetery. This project helped to gain attention for this new architect and led to countless other commissions.

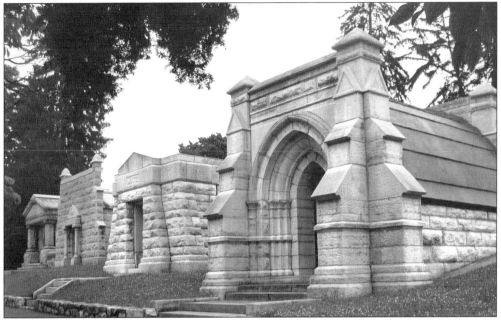

Mauseleum Row at Thornrose Cemetery. T.J. Collins designed an entire row of five mausoleums in Thornrose Cemetery. Architect-designed mausoleums are rarely found together, especially an entire row of them. Collins carefully placed each of these structures on a curved stretch of roadway that adds greatly to their overall dramatic effect.

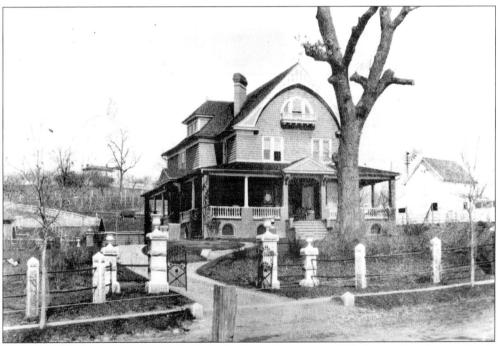

The Henry L. Lang Mansion. Probably built for the owner of H.L. Lang's Jewelers on North Augusta Street, this house was designed by T.J. Collins. It was used for a number of years as a nurse's dormitory for King's Daughters Hospital. It was demolished c. 1970.

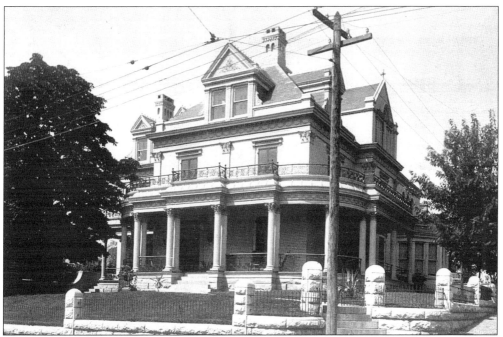

THE EFFINGER MANSION. T.J. Collins remodeled a Greek revival house into a Beaux Arts confection for the Effinger family during the late 19th century. Collins also designed a permanent home for the Effinger family in the form of a small chapel—their family mausoleum at Staunton's Thornrose Cemetery. (Courtesy of the Hamrick Collection.)

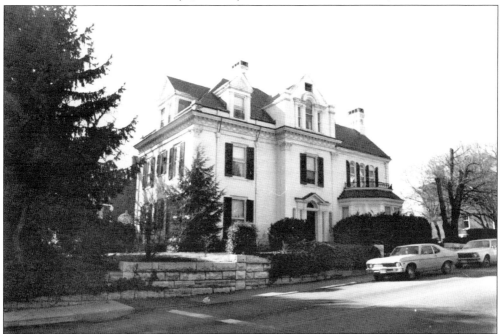

THE EFFINGER MANSION TODAY. Although the Effinger Mansion survives as part of the Woodrow Wilson Presidential Library, the elaborate porch is gone. (Courtesy of Historic Staunton Foundation.)

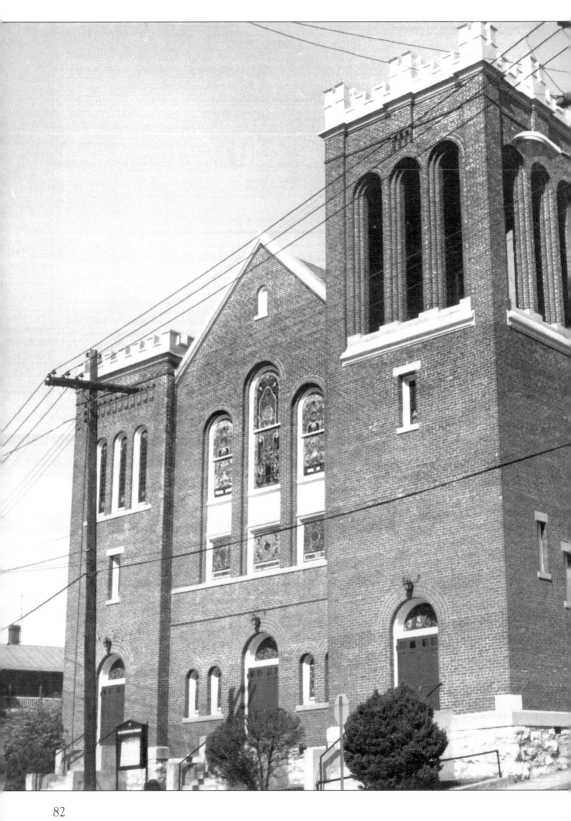

MT. ZION BAPTIST CHURCH. In 1866, this congregation began to hold services in various churches; eventually, they rented a small log cabin on Frederick Street (now part of the Mary Baldwin College campus). In 1870, a new church was built on the corner of Sunnyside and Baptist Streets. Although this church building has vanished, the former parsonage from this era survives as a private residence. In 1904, T.J. Collins designed a new Romanesque revival–style church at Augusta and Points Streets. The fortress-like Romanesque style seemed appropriate for churches, as it symbolized the strength of faith.

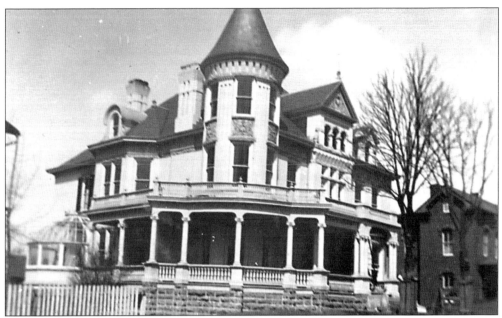

THE C.W. MILLER HOUSE. This extraordinary house was commissioned by Mr. Miller's wife from T.J. Collins in 1894. The cream-colored brick house is in the Queen Anne style with characteristics of the châteauesque. For years, the house was owned by Mary Baldwin College and used for the music department. Later, it housed the development office before again becoming a single family home at the end of the century. The interior features remarkable woodwork, and a modern conservatory has been constructed on the footprint of the original, which was removed in the late 1940s. Today, the only missing exterior feature is the balustrade along the roof of the wrap-around porch; both are visible in this mid-1940s photo. The Eastlake-style house to the right, which also survives, was built c. 1886 by William Wholey, an Irishman who made his fortune producing whiskey. (Courtesy of the Hamrick Collection.)

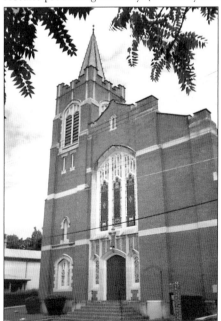

AUGUSTA STREET METHODIST CHURCH. The original church, built on the southwest corner of New and Prospect Streets in 1869, was replaced in 1878 with a larger structure at Augusta and Prospect Streets. After the old building was demolished, the property was sold for the construction of three Italianate-style houses that survive along North New Street. Still in use by the congregation, Augusta Street Methodist received a new Gothic revival–style façade in 1910, designed by T.J. Collins.

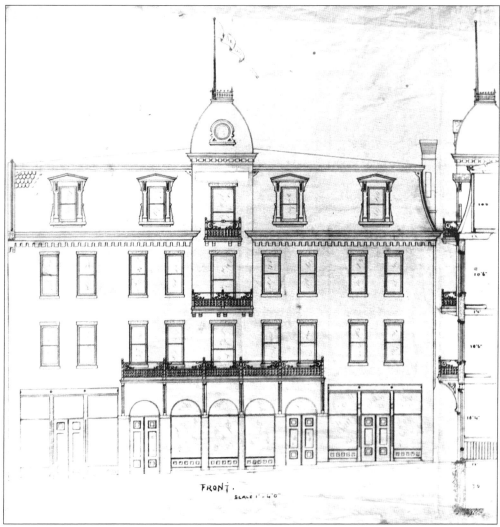

FRONT.
SCALE 1" = 4'0"

THE EAKLETON HOTEL. By the end of the 19th century, the Chesapeake & Ohio and Baltimore & Ohio Railroads were bringing countless passengers into the heart of Staunton. The downtown area had numerous hotels that catered to railroad passengers, and the Eakleton Hotel, designed by T.J. Collins in 1894, was one of the finest. The French Second Empire–style building had a Mansard roof and tower, iron balconies, and ornamental terra cotta details on the façade that have recently been restored in accordance with the surviving original building plans. The renovation was part of a project to transform this long-empty building into the R.R. Smith Historic and Art Center. Woodrow Wilson stayed here in 1911 during a brief visit while he was governor of New Jersey. This architectural rendering by T.J. Collins shows the façade of the Eakleton Hotel.

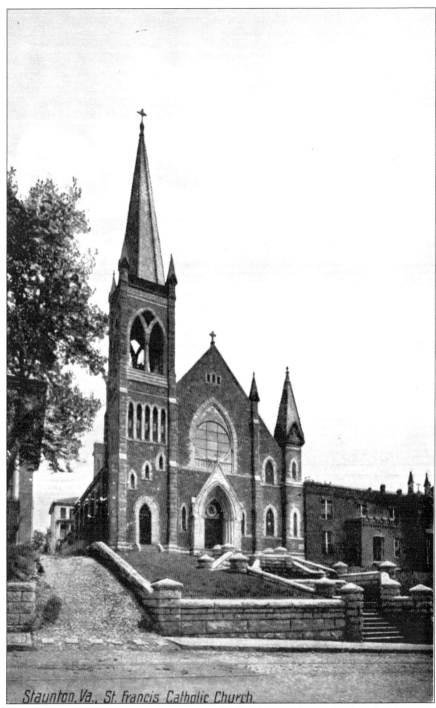

Staunton, Va., St. Francis Catholic Church.

St. Francis Catholic Church. One of T.J. Collins's most dramatic churches is one that he designed for his own congregation. Placed on a steep hillside, with entrance steps that spread out in a zigzag fashion, the church's overall vertical design with two pointed spires creates an imposing Gothic structure. The multi-colored façade features green and buff shades of limestone. The church replaced the previous Catholic church built in 1851.

86

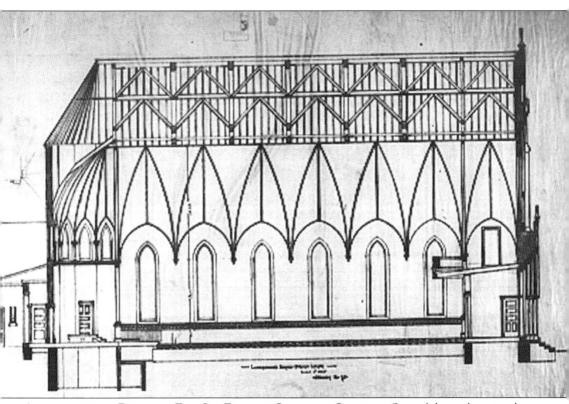

ARCHITECTURAL DRAWING FOR ST. FRANCIS CATHOLIC CHURCH. One of the architectural plans by T.J. Collins for St. Francis shows the vaulted ceiling in the sanctuary.

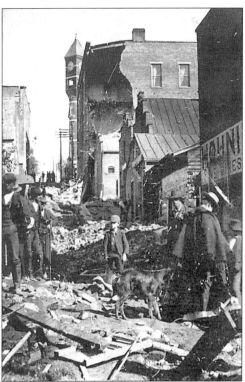

THE 1896 FLOOD. A major flood on September 29, 1896, caused extensive damage to buildings throughout the Wharf and downtown area including the Crowle building to the right. Its back corner was rebuilt, and the structure survives.

THE REAR OF THE CROWLE BUILDING. This view of the rear of the Crowle building faces the Town Clock Building.

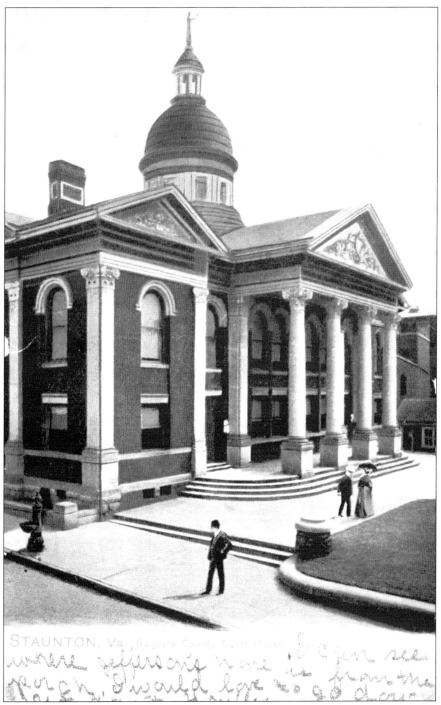

STAUNTON, Va., Augusta County Court House

THE AUGUSTA COUNTY COURTHOUSE. After receiving the commission to replace the Thomas Blackburn–designed courthouse built in 1836, T.J. Collins transformed the classical revival–style building into an elaborate Beaux Arts–style building with red and cream colored brick, cream colored terra cotta capitals, and a tall dome appropriately topped with the figure of Justice.

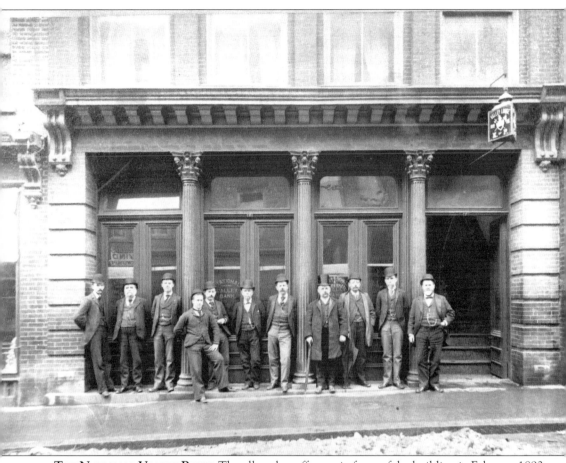

THE NATIONAL VALLEY BANK. The all-male staff poses in front of the building in February 1892. The overhanging cornice supported by large brackets and the elaborate Corinthian pilasters reflect the Italianate style that was so popular in Virginia post–Civil War. The pilasters appear to have been cast iron, a popular building material of the era. Note the steep staircase, which led to the lodge room of the Knights of Pythias upstairs in the building to the right. Since the Civil War destroyed all of the banks in the South, former Confederate general John Echols of Staunton went to Baltimore in 1865 and convinced Enoch Pratt to invest capital to start this bank. (Courtesy of the Hamrick Collection.)

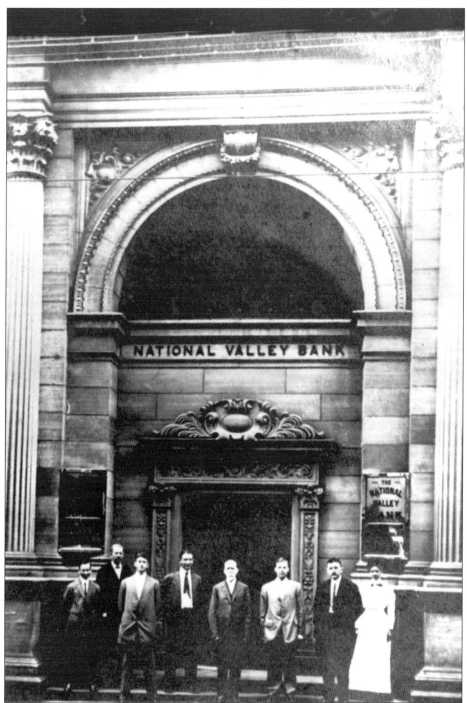

THE NEW NATIONAL VALLEY BANK. One of T.J. Collins's finest creations was the National Valley Bank of 1903, built on the site of the previous bank building. Inspired by the ancient Arch of Titus in Rome, the handsome new bank featured an elaborately carved limestone façade and an ornate interior in the Beaux Arts tradition. This view shows the bank staff in front during the early years of the new building. (Courtesy of the Hamrick Collection.)

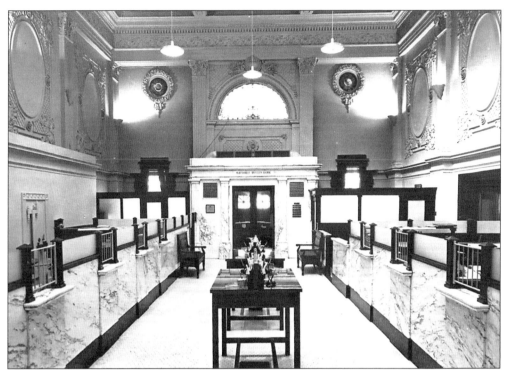

THE NEW NATIONAL VALLEY BANK. This is the interior of the bank as it appeared during the 1960s. With the exception of the modern hanging light fixtures and the right row of bank tellers, the interior is remarkably intact and is still used as a bank.

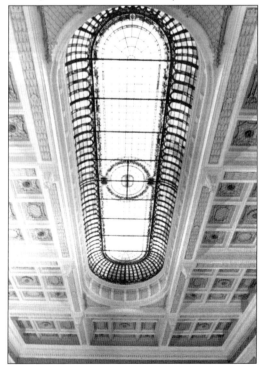

STAINED GLASS DOME IN THE NATIONAL VALLEY BANK. One of the most handsome features of the interior of the new National Valley Bank building as designed by T.J. Collins is a magnificent coffered ceiling with an oblong stained glass dome.

THE ENTRANCE ARCHWAY TO THE SMITH FUEL COMPANY ICE FACTORY. Designed by T.J. Collins in 1910, this complex of buildings included an ice factory located near the center of the block, accessible by a driveway through this archway.

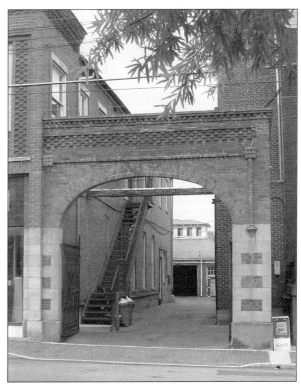

THE ENTRANCE ARCHWAY TO THE SMITH FUEL COMPANY ICE FACTORY IN DETAIL. The entrance archway of the ice factory shows details inspired by the designs of the great Chicago architect Louis Sullivan.

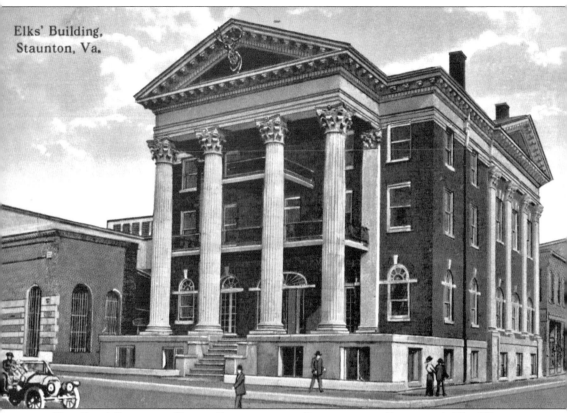

Elks' Building,
Staunton, Va.

THE ELKS' BUILDING (LATER RE-NAMED THE PROFESSIONAL BUILDING). The Elks was just one of numerous fraternal organizations that occupied large buildings in downtown Staunton. This structure was designed by T.J. Collins in 1912 and was built in the Beaux Arts tradition and boasted a monumental portico with elaborate Corinthian columns. It was constructed of contrasting cream and red colored brick and limestone trim, similar to the treatment used for the Augusta County Courthouse. Its columns were comprised of large blocks of molded cream colored terra cotta, which resembles stone but was less expensive. A giant elk's head projected from the pediment of the porch, which is the only major feature of this building that no longer survives. Like most other fraternal organization that built their own buildings in Staunton, this one housed not only meeting space for the Elks, but office space that they leased for income.

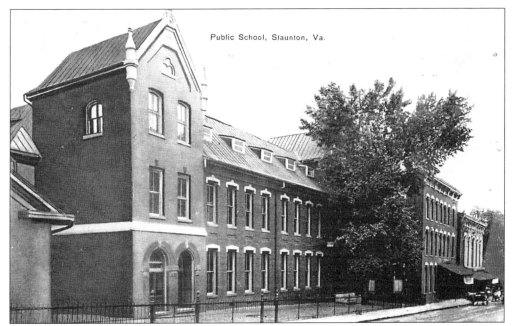

STAUNTON'S FIRST PUBLIC SCHOOL. The Stonewall Jackson School was originally built in 1887 as Staunton's first public school building. Located on Beverley Street directly across from Trinity Episcopal Church, the school has been used for most of its existence for educational purposes.

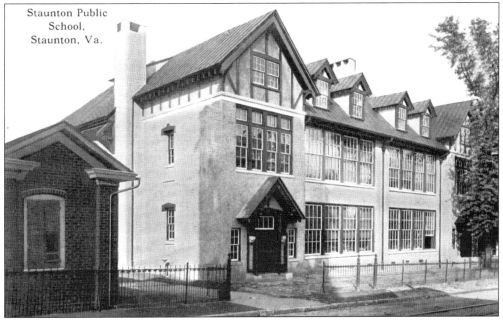

STONEWALL JACKSON SCHOOL REMODELED BY T.J. COLLINS. The Stonewall Jackson School was greatly remodeled in 1912 and 1913 by T.J. Collins in a Tudor revival–style with elements of the arts and crafts movement and huge windows that infused the classrooms with natural light. When President-elect Woodrow Wilson came to Staunton in December 1912, the reviewing stand for a parade in his honor was in front of this school.

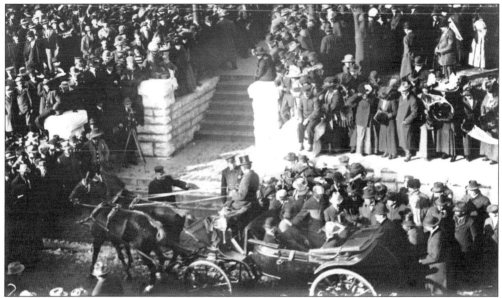

PRESIDENT-ELECT WOODROW WILSON VISITS STAUNTON. On December 28, 1912, Staunton honored its native son Woodrow Wilson, who had just been elected president of the United States. While in Staunton, Wilson spoke to the citizens of the city from the front portico of the main building of Mary Baldwin College, where his father had served as principal as well as minister of the First Presbyterian Church next door. Wilson is shown arriving by carriage to the entrance. Notice the handsome stone retaining walls that began to appear in Staunton as streets were widened during the last quarter of the 19th century. Local limestone blocks used to construct these walls throughout the city. The main building at Mary Baldwin is one of several Greek revival–style school buildings constructed in Staunton during the 1840s and 1850s. President Dwight Eisenhower, whose mother was from the area, spoke from this same portico in 1960. (Courtesy of the Hamrick Collection.)

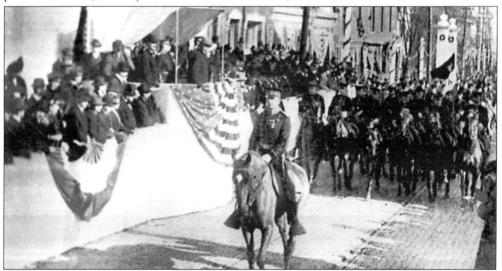

PRESIDENT-ELECT WOODROW WILSON. For the parade honoring President-elect Woodrow Wilson, a reviewing stand was set up in front of the Stonewall Jackson School (facing Trinity Church). (Courtesy of Historic Staunton Foundation.)

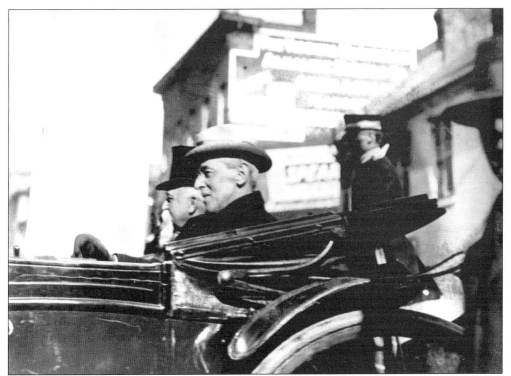

PRESIDENT-ELECT WOODROW WILSON. Wilson is shown in the car that chauffeured him around Staunton during his visit in December 1912. (Courtesy of Historic Staunton Foundation.)

DECORATIONS FOR WOODROW WILSON'S VISIT. In honor of Staunton's favorite son, Staunton's streets were elaborately decorated with electric lights, columns, and lots of bunting. This photograph is looking down Beverley Street from North Coalter Street. Notice the trolley coming up the hill. (Courtesy of Historic Staunton Foundation.)

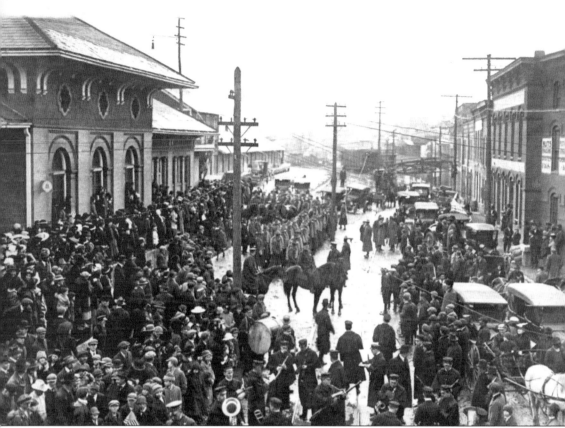

TROOPS AT T.J. COLLINS'S RAILROAD STATION. When President Woodrow Wilson became involved in trying to preserve democracy in Mexico, local troops boarded trains at Staunton's railroad station. In this picture taken in 1917, the Stonewall Brigade Band can be seen in the foreground. Established in 1855 as the Mountain Sax Horn Band, the name was changed during the Civil War when most of the band members served under Stonewall Jackson. Beginning in the 1870s, the city provided some financial support for the band, and the Stonewall Brigade Band is now the oldest continuously performing band in the nation to receive municipal support. The station, built in 1905 and designed by T.J. Collins, has features of both the bungalow and mission styles. At some point over the years, the elaborate windows under the overhanging eaves were filled in. The Italianate-style warehouse buildings to the right were built from the 1880s into the first decade of the 20th century, replacing structures burned by General Hunter's troops during the Civil War.

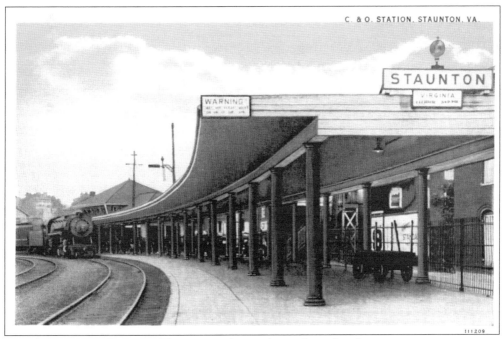

C & O Railroad Station. This post card view shows the railroad station concourse.

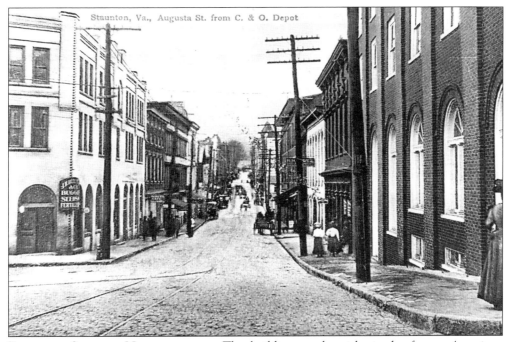

Railroad Station Neighborhood. The building to the right is the former American Hotel building, afterward used as a wholesale grocery warehouse. The following building in the Italianate style was built during the 1880s. (Courtesy of the Hamrick Collection.)

THE WHARF. One of the most puzzling names for a Staunton neighborhood is the Wharf, since Staunton is not located along the banks of a river. Warehouses that traditionally are built near wharfs were constructed in Staunton close to the railroad station, and at some point, someone must have thought that the area was reminiscent of a wharf. In fact, one could argue that the railroad acts in the same fashion as a wharf, only using rail rather than ships to transport goods. Since General Hunter destroyed the buildings in this area in 1864, with the exception of the American Hotel building, all of the structures surrounding the station were built post–Civil War, primarily between the 1880s and early 20th century. Originally constructed as warehouses, the buildings now house shops and apartments.

RAILROAD STATION AREA. This photograph from 1912 shows street decorations for President-elect Woodrow Wilson's visit. The most extraordinary feature of the building to the right, restored in 2003 after years of neglect, is the elaborate tin cornice, which came off during a 1970s storm. Pieces were salvaged by local potter Jim Hanger and offered to the owners who were not interested in restoring it. Decades later, a new owner decided the cornice should be replaced; after many painstaking months of research, repair, and fabrication of missing components, the cornice was returned to the building. (Courtesy of the Hamrick Collection.)

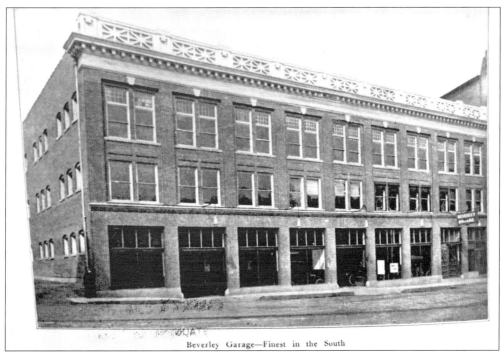

Beverley Garage—Finest in the South

THE BEVERLEY GARAGE. The Beverley garage, with classical ornamentation, was designed by T.J. Collins c. 1912. At the time, this was the largest automobile garage in the South. Huge windows on three sides of the building flooded the interior with natural light, and an elevator took automobiles to the upper levels. Appropriately, the building is used today as an antique and classic automobile business.

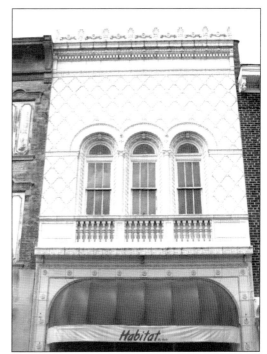

SWITZER JEWELRY STORE. This pre-existing building received a new façade designed by T.J. Collins in 1911 in the Venetian revival–style. White glazed terra tiles create a marvelous confection that looks somewhat like a jewelry box, appropriate since the client was Switzer Jewelers.

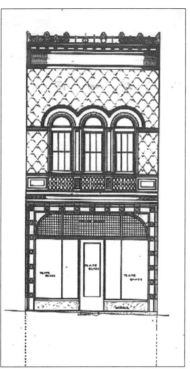

ARCHITECTURAL DRAWING FOR THE SWITZER JEWELRY STORE. Here are plans for the new Venetian revival–style façade. (Courtesy of Historic Staunton Foundation.)

SWITZER JEWELRY STORE IN DETAIL. Shown here in detail are the ornate Venetian tiles used to decorate this building.

WHOLEY AND WITZ BUILDINGS. T.J. Collins designed these buildings for prominent families during the early 20th century. The building to the far right was constructed for shops and offices in 1906 in the Colonial revival–style for the Witz family. Collins would later receive another commission from Witz to design the New Theatre. The second building from the right was constructed for the Wholey family in 1899 and was inspired by 14th-century Venetian palazzos. This is one of two surviving commercial buildings on Staunton's main street with façades made up entirely of cut stonework. The Wholey family members were some of the leading purveyors of alcoholic beverages in a city that was very fond of such products. Note the electric trolley as well as the horse-drawn buggy sharing the street in this image from around 1910.

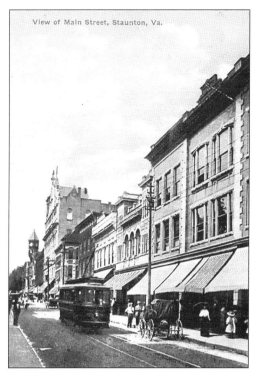

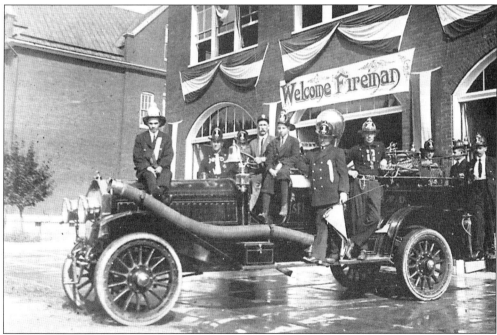

"JUMBO." In 1911, Staunton's fire department became the first in Virginia to purchase a motorized firefighting apparatus. The Robinson Chemical Fire Engine, manufactured in St. Louis, is the only surviving fire engine of its kind in existence. It is shown here in front of the old fire station shortly after it was purchased. Staunton's fire department, one of the oldest in Virginia, was established in 1790 and included one female member.

THEATRE ROW. The former Grange Hall was purchased by the City and became an opera house, later known as the Beverley Theatre. The large auditorium attracted many of the most prominent performers of the day including Lillie Lantry, DeWolf Hopper, William S. Hart, Lillian Russell, and Otis Skinner, to name a few. This image from December 1912 shows the street decorations and elaborate bunting on the Beverley Theatre in preparation for the visit by President-elect Woodrow Wilson. The Italianate façade was removed when the building was extended a few feet toward the street; Sam Collins added a new façade in 1930 to enhance the Georgian revival design. To the right of the Beverley Theatre is the Arcadia building, which was designed by T.J. Collins for the Odd Fellows and which at various times included theatres. The building under construction next door is the New Theatre (later called the Dixie), designed by T.J. Collins and Son; notice the lack of a projecting marquee, which would be added eventually. (Courtesy of the Hamrick Collection.)

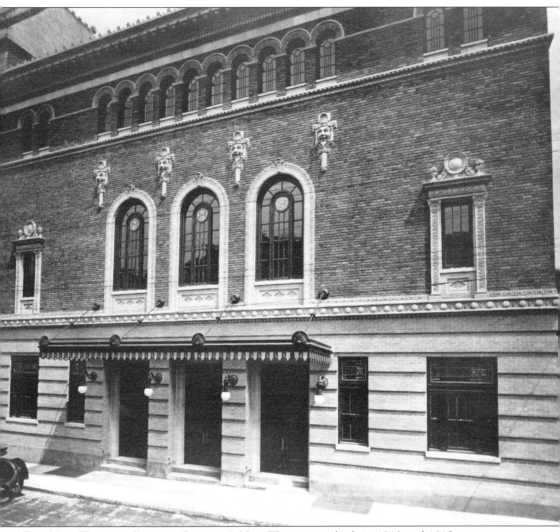

THE NEW THEATRE FAÇADE. Staunton's New Theatre was built in 1912 and 1913 as a venue for vaudeville shows and silent movies. The prominent Staunton architect Thomas Jasper Collins (1844–1925) came out of retirement to assist his sons William M. (1874–1953) and Samuel J. (1881–1953) on the design for this building, which was their last collaboration. The exterior design was in the Italian Renaissance revival–style inspired by Renaissance era palazzos in Florence, such as the Palazzo Riccardi (1444–1460). Horticultural Hall in Philadelphia, designed in the late 1890s by Frank Miles Day & Brothers and inspired by Florentine palazzos, is believed to have provided the inspiration for the design of Staunton's New Theatre. (Courtesy of the Hamrick Collection.)

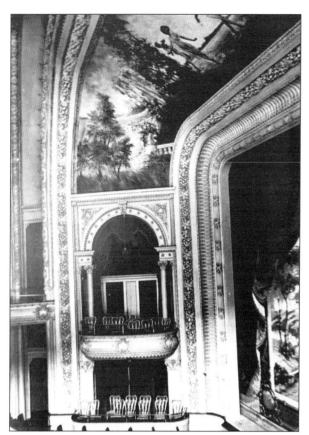

THE NEW THEATRE INTERIOR. The New Theatre featured a richly ornamented interior with ornate, gilded plasterwork, a mural above the stage, two balconies (the upper of which was the "colored section" and was accessed only by a staircase that led to a side entrance), and box seats on either side of the stage. The level under the stage had an orchestra room, two chorus rooms, six individual dressing rooms, and a property room for sets. When completed, the New Theatre was probably the most state-of-the art theatre in Virginia, and even had an early form of air conditioning. (Courtesy of the Hamrick Collection.)

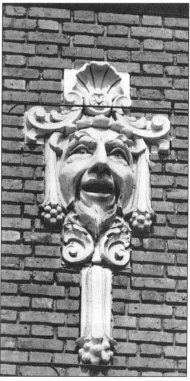

TERRA COTTA MASK ON THE FAÇADE OF THE NEW THEATRE. The New Theatre opened on June 16, 1913, with a combination of live entertainment and film. The bill featured Keith's Refined Vaudeville; the Empire Comedy Four, "vaudeville's greatest comedy quartet;" "the artistic trio" in a musical offering; Fed and Annie Pelot, "a comedy, talking, and juggling act;" plus "the latest films." This is one of four terra cotta masks that line to the top of the façade of the building.

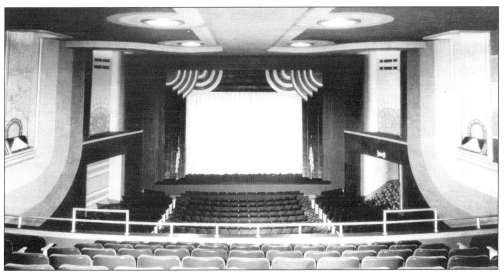

THE DIXIE THEATRE. After the theatre burned in 1936, it was rebuilt without the third floor but with exterior features of the original building, such as four terra cotta masks and the arched windows with decorative tiles. The destroyed interior was transformed by theatre architect John Eberson into an art moderne style, and the rebuilt theatre was renamed the Dixie. Eberson gained national prominence during the 1920s for his "atmospheric" theatres; in Richmond, Virginia, he designed not only Loew's Theatre (now the Carpenter Center for the Performing Arts), but also the Broad-Grace Arcade and Central National Bank building, both of which survive with different names. (Courtesy of the Hamrick Collection.)

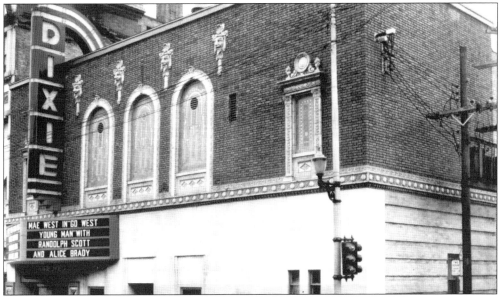

THE DIXIE THEATRE. As the 1930s continued, a new style emerged known as art moderne, a cheaper version of art deco that used streamlined forms and less expensive materials while concentrating on bright colors and dramatic lighting. This style was greatly influenced by ocean liners of the era; the new interior for the Dixie Theatre, especially in the lobby areas, has a ship-like atmosphere. The new "Dixie" sign reflected this new style. (Courtesy of the Staunton Performing Arts Center.)

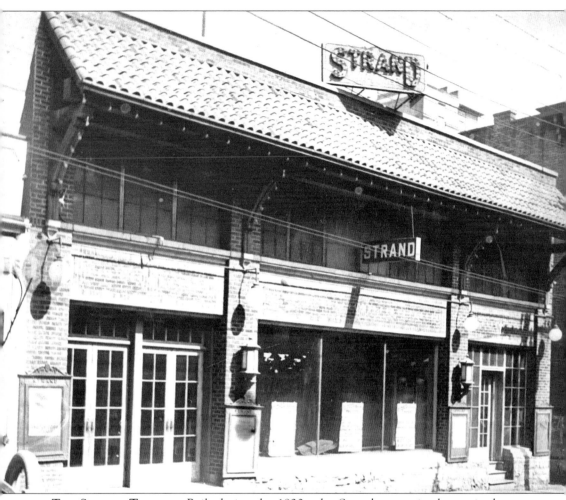

THE STRAND THEATRE. Built during the 1920s, the Strand was a simple movie theatre on South New Street near the entrance to the New Street garage. It was demolished during the 1970s. (Courtesy of the Hamrick Collection.)

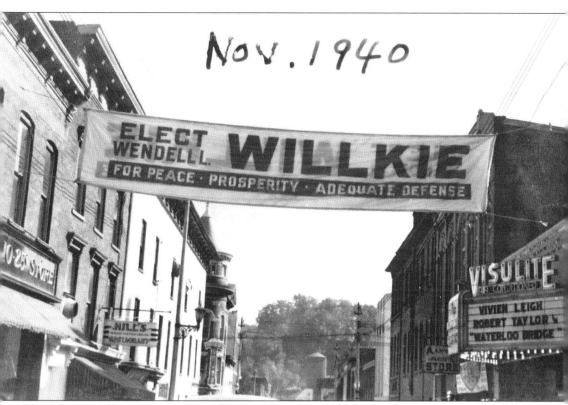

THE VISULITE THEATRE. Built in 1937 on North Augusta Street, this was one of a small theatre chains in Virginia and North Carolina; the Visulite chain featured the projection of movies from the rear of the screen rather than the usual custom of projecting the film from the rear of the auditorium. The interior originally featured a brightly colored, patterned ceiling and decorative wall sconces along the north wall of the auditorium. The doors from the lobby into the auditorium were upholstered with bright red leather-like material with gold decorative tacks. Brick patterns used on the façade have been lost to layers of paint. The marquee has since been remodeled from the one shown here to a shallow and triangular one because of the narrow sidewalk in front, with the name "Visulite" on one side and a large "V" on the other.

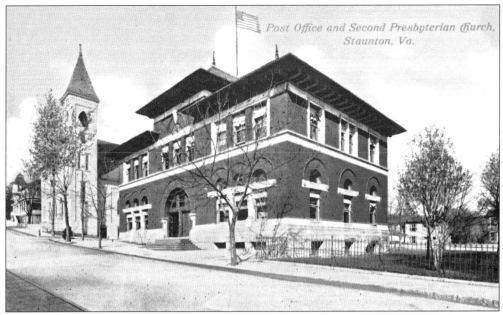

Post Office and Second Presbyterian Church, Staunton, Va.

STAUNTON POST OFFICE. This Staunton Post Office building, shown here in 1923, operated from the 1880s until the early 1930s when it was replaced with a more modern WPA post office. This Romanesque revival–style post office featured a limestone foundation and large arched windows and entrance doorway. When it was demolished, the stone foundation was salvaged and used as a retaining wall for a private home at 401 North New Street. The church to the left of the post office is the Second Presbyterian Church, which still stands and is somewhat unusual in that it appears to have been painted white from an early date.

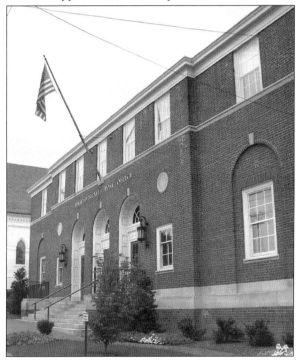

STAUNTON POST OFFICE. The present downtown post office, designed by architect Louis A. Simon, was constructed in 1935 in the Colonial revival style that was gaining popularity due largely to the restoration of John D. Rockefeller in Colonial Williamsburg.

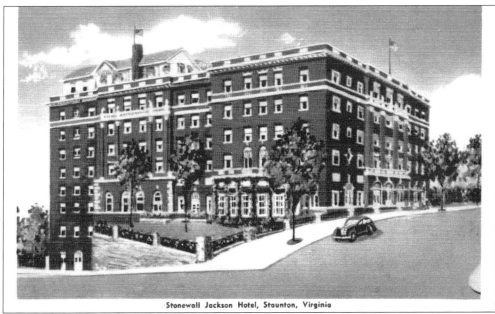

Stonewall Jackson Hotel, Staunton, Virginia

THE STONEWALL JACKSON HOTEL. When it opened in 1924, this Colonial revival–style hotel was considered the ultimate in luxury. Designed by New York architects, H.L. Stevens & Company, each room featured the latest in modern amenities including ice water on tap. A Wurlitzer organ on the mezzanine level provided music to entertain guests in the lobby and dining rooms simultaneously. Amelia Earhart was just one of the many notables who stayed here. A giant neon sign on the roof was added around 1950 and has become a major downtown landmark. To the immediate left of the Stonewall Jackson Hotel is the old Virginia Hotel, and to the left of that is the old Eakleton Hotel; this appears to be a deliberate attempt to show how much more modern the new hotel was in comparison to the earlier ones.

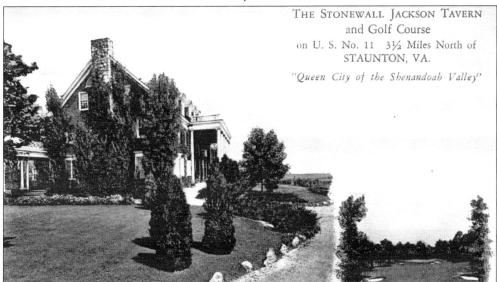

THE STONEWALL JACKSON TAVERN
and Golf Course
on U. S. No. 11 3½ Miles North of
STAUNTON, VA.

"Queen City of the Shenandoah Valley"

THE STONEWALL JACKSON TAVERN AND GOLF COURSE. This facility was developed and operated by the Stonewall Jackson Hotel in downtown Staunton as a golf course for its guests. The property would later become Ingleside Resort and Country Club.

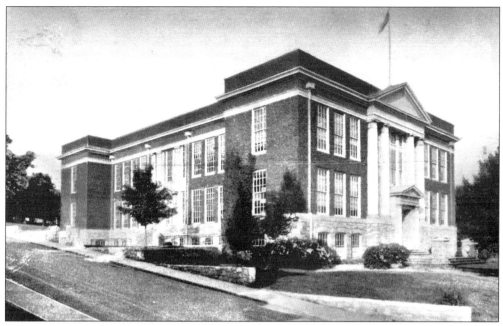

THOMAS JEFFERSON GRAMMAR SCHOOL. Designed by T.J. Collins using classical elements, this former school has since been converted into the Staunton Public Library.

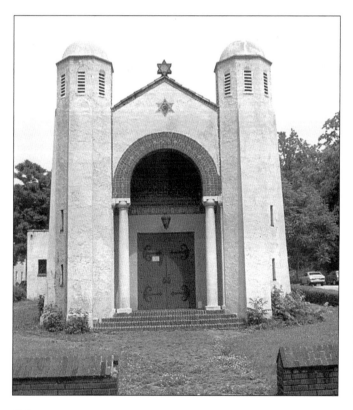

TEMPLE HOUSE OF ISRAEL. This building, designed by Sam Collins of T.J. Collins and Son, includes Mercer tiles in the façade, and the interior has a collection of windows and a glass screen by the firm of Charles Connick of Boston. The Connick firm gained attention during the early 20th century in its efforts to re-create medieval stained glass techniques; it produced such windows for buildings nationwide including one for St. John the Divine in New York City. The Temple House is one of the few buildings in which every window is the work of the Connick firm.

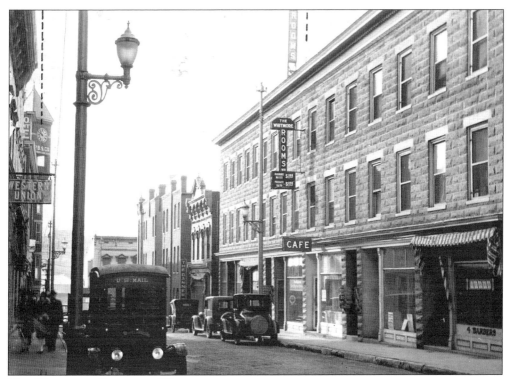

The Whitmore Building. This view from around 1925 looks down Central Avenue from just south of Frederick Street. The Whitmore building, constructed in 1903, is shown to the right and survived until the 1980s.

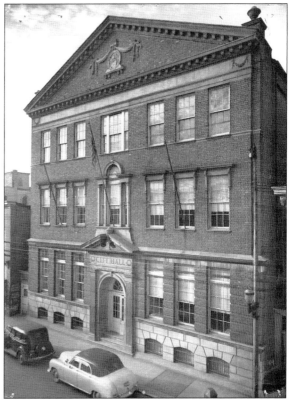

Staunton City Courts Building (Old City Hall). The old Grange Hall, which later became the Beverley Theatre and housed city offices, finally became city hall in 1930 after Staunton decided to expand the building for office use only. Sam Collins of T.J. Collins and Son expanded the building several feet closer to the street and added a Colonial revival–style brick façade with limestone trim. (Courtesy Greater Augusta Regional Chamber of Commerce.)

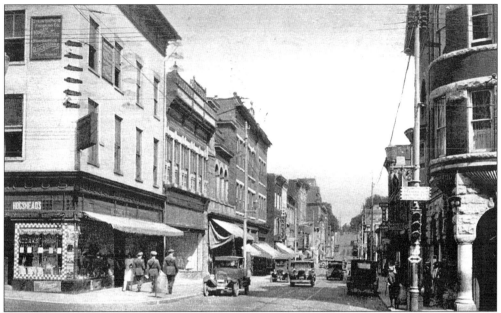

BEVERLEY STREET BUSINESS DISTRICT. Beverley Street, Staunton's main street, is shown *c*. 1930 looking east from Augusta Street toward the intersection of New Street. The building on the left was then Hogsheads Drug Store, a local landmark for many years, and the building on the right is the Marquis building, designed by T.J. Collins in 1894.

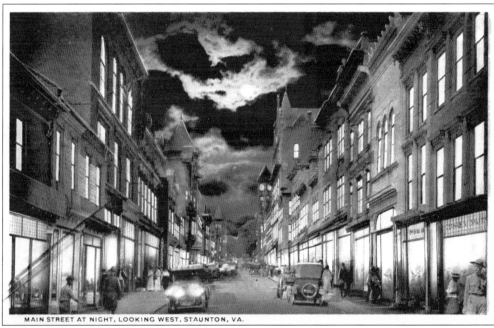

BEVERLEY STREET BUSINESS DISTRICT. This night view shows Beverley Street facing west from New Street toward Augusta Street *c*. 1929. Notice all of the people on the street, the illuminated shop windows, and the town clock at the far end of the street. The third building on the right (light colored) is the Switzer Jewelers building designed by T.J. Collins in the Venetian revival style.

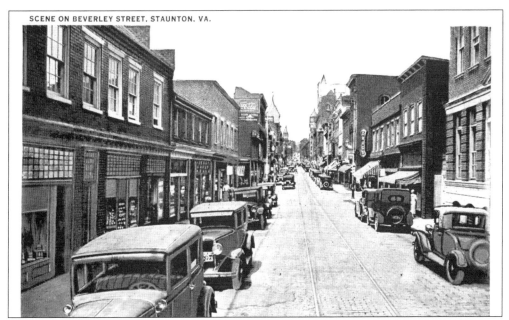

BEVERLEY STREET BUSINESS DISTRICT. Beverley Street is shown here facing west between Market and New Streets during the 1930s. On the far right is a corner of the Staunton city hall, now the city courts building. The buildings on the left are from the 1830s, but the storefronts were remodeled during the early 20th century with display windows. Note that the narrow street was two-way with parking allowed on both sides and trolley tracks down the middle of the brick-paved street.

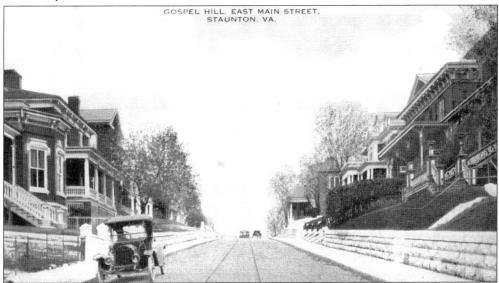

BEVERLEY STREET RESIDENTIAL DISTRICT. This is a 1930s view of East Beverley Street from the next block east. Market Street has long been the dividing line between the commercial and residential portions of Beverley Street, with the exception of the Hardy Carriage Works, which was located east of this intersection until it burned in 1928. All of the houses in this photograph survive. The one-story bay on the left has since been turned into a two-story structure. Note the trolley near the top of the hill.

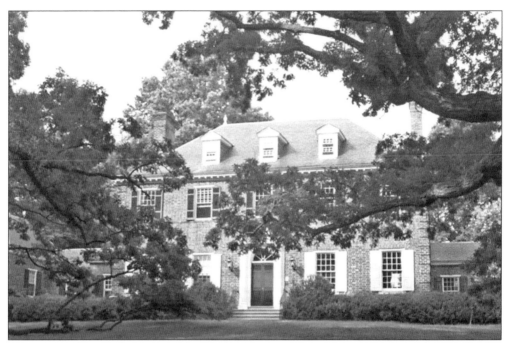

WAVERLEY HILL. Built from 1928 to 1930 as the residence for Herbert McKelden Smith, this Colonial revival–style mansion was designed by the prominent New York architect William Lawrence Bottomley, who designed many grand houses in Tidewater Virginia. The Smith family operated a coal and ice business in Staunton. This house commands the top of a hill on the northern end of the city and has remained in the hands of the Smith family. This is certainly one of finest residences designed by Bottomley in Virginia.

BOOKER T. WASHINGTON HIGH SCHOOL. Built in 1930 as the area's first "fireproof" building, this was the high school for Staunton's African-American students. The art moderne–style building was constructed of re-enforced concrete with a brick veneer and decorative cast concrete ornaments. The school became obsolete with integration and stood vacant for many years before being converted into a community center.

Seven

DECLINE AND REBIRTH

URBAN RENEWAL. By the 1960s, Staunton's downtown area was experiencing a decline in popularity, like so many American cities during the era. Staunton's approach to the problem was the same as well: bulldoze the buildings and create something new. Despite opposition from the public and from business owners, a large area containing 32 buildings in the block bounded by Central Avenue and Augusta, Frederick, and Pump Streets was cleared, although there were no plans in place for redeveloping the site. For years, the expanse of land stood empty until several banks were convinced to build new baking centers along the strip. Several years later, the Virginia Department of Transportation (VDOT) announced plans for a major road that would have demolished the historic railroad station complex, as well as many of the surrounding historic buildings in what is now the Wharf Historic District. The Historic Staunton Foundation, formed in 1971, successfully aborted the road plans. The once blighted area has been restored and has become one of Staunton's most popular neighborhoods to visit by both tourists and locals.

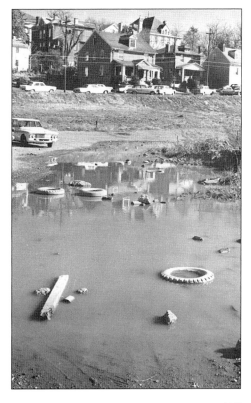

THE BELLE GRAE INN. During the 1980s, Staunton's first inn was created in the former Bagby home, a Victorian mansion from the 1880s. By this time, the Newtown neighborhood had seen better days, and the new inn would be developed in a portion of the neighborhood that was particularly run-down. The addition of a new restaurant to the Victorian home helped to lure tourists and locals alike to this neighborhood that would otherwise have been ignored. Newtown, Staunton's oldest residential neighborhood, has become a popular place to live again thanks to the vision of a few people who have rescued buildings for this inn and for residences over the past few decades.

PRESERVATION AS PROGRESS: WHARF PARKING LOT. Within a few years of its establishment in 1971, the Historic Staunton Foundation (HSF), through active efforts to encourage restoration of Staunton's historic buildings, managed to demonstrate that "preservation is progress." The Wharf parking lot was re-designed to become more pedestrian friendly, and the once derelict old warehouse along the south side of the lot has been renovated over the last three decades.

OLD LEGGETT'S DEPARTMENT STORE. Until it was remodeled for Staunton's new city hall in the early 1990s, Leggett's was actually two 19th-century buildings remodeled beyond

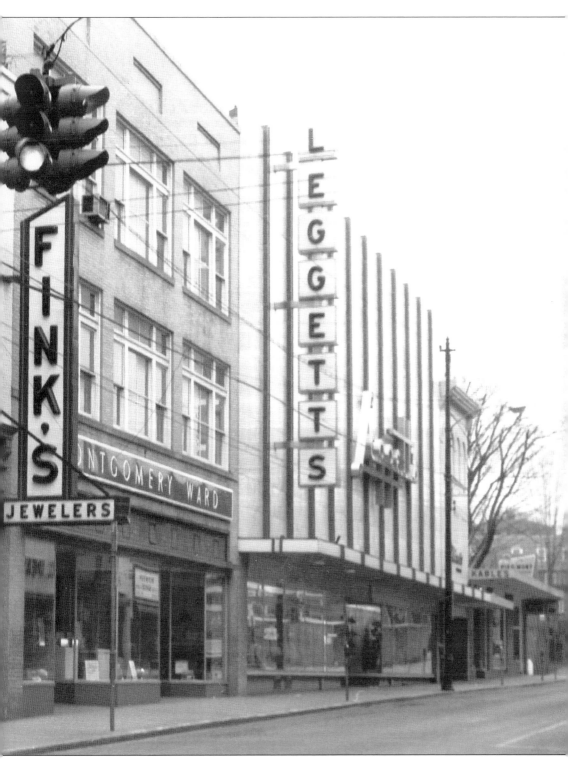

recognition. Its redevelopment helped to jumpstart other projects in the area.

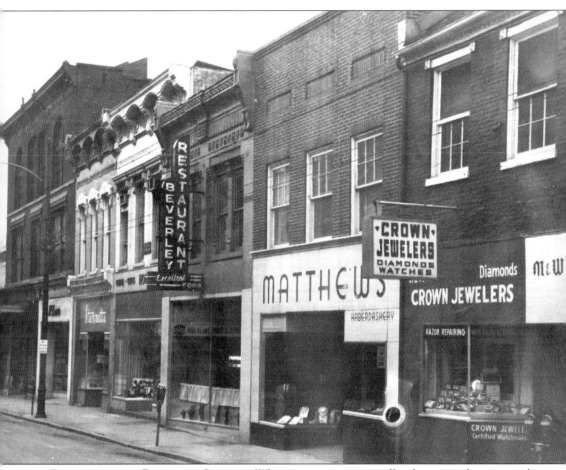

DECAY ALONG BEVERLEY STREET. What was once a rapidly decaying downtown has blossomed into one of Virginia's most thriving areas, and many millions of dollars have been spent renovating Staunton's historic buildings. Various groups have followed, such as the Staunton Downtown Development Association (SDDA), which currently promotes downtown, but it is because of the work of Historic Staunton Foundation that there exists a downtown to promote.

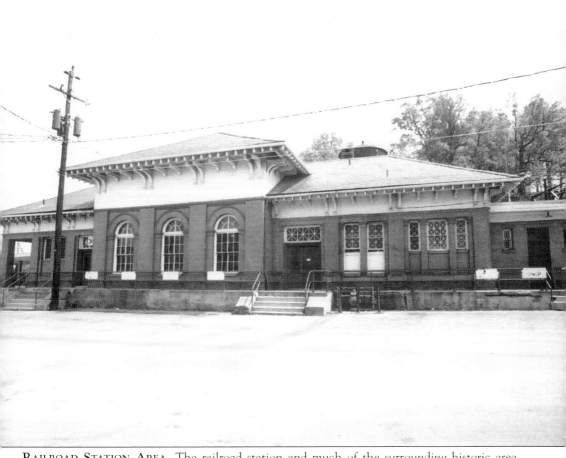

RAILROAD STATION AREA. The railroad station and much of the surrounding historic area were largely abandoned and in disrepair until the late 1980s when Vic Meinert jumpstarted the preservation efforts in this part of downtown by renovating the railroad station complex.

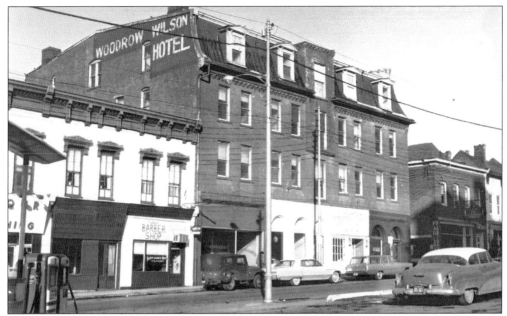

EAKLETON HOTEL BUILDING. By the 1960s, what was once the finest hotel in the city had become a major eyesore. Over the years, the hotel went through several names, including the Woodrow Wilson Hotel. Many of the architectural features, including the cupola dome, decorative terra cotta panels, and iron balconies, had vanished.

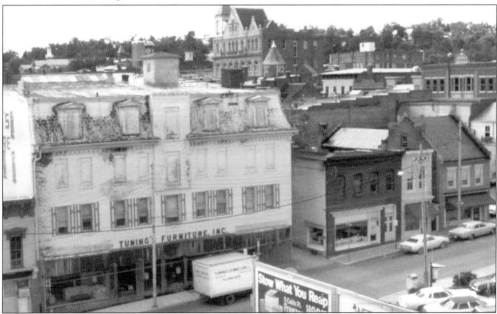

DOWNTOWN. By the early 1970s, downtown Staunton was looking pretty shabby. The former Eakleton Hotel had become a furniture store and had lost many of the architectural element that made the building a major landmark of distinction. The block of buildings across the street had been bulldozed and replaced with a surface parking lot and billboard. The threat to Staunton's historic fabric, especially in the downtown area, led to the creation of the Historic Staunton Foundation in 1971.

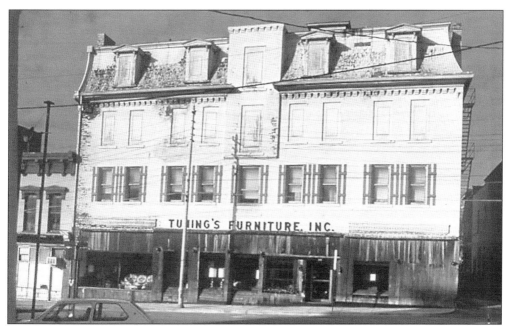

EAKLETON HOTEL BUILDING. The last occupant, the Tuning Furniture Store, moved out in 1989, and the structure stood vacant except for the hundreds of pigeons that had taken up residency until three organizations joined forces to renovate the building for use as a center for history and art.

EAKLETON HOTEL BUILDING (THE R.R. SMITH CENTER FOR HISTORY AND ART). This re-claimed architectural gem will be the new home for the Augusta County Historical Society, the Historic Staunton Foundation, and the Staunton-Augusta Art Center. The building will house the extraordinary collection of surviving architectural drawings produced by the T.J. Collins firm, and they will reside in a building that was designed by the firm.

NEW STREET PARKING GARAGE. Staunton's New Street parking garage, designed by the Staunton firm of Frazier Associates, gained national attention and won several major design awards shortly after its completion in 2001. The architects skillfully managed to design a huge parking structure that not only accommodated 277 automobiles, but would also blend in with surrounding historic buildings. The southern façade is reminiscent of a railroad station, while the New Street façade conveys the impression of a row of seven different ones rather than that of a large parking facility.

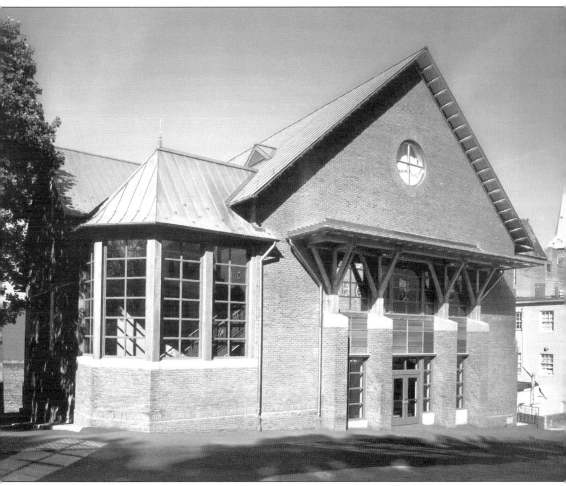

THE BLACKFRIARS PLAYHOUSE. This is the only re-creation in the world of the interior theatre that was owned by William Shakespeare in London. The Staunton playhouse was built in 2001 as the first permanent home for Shenandoah Shakespeare, and architect Tom McLaughlin did extensive research for the design. He purposely planned a handsome exterior that would blend in with the historic surroundings while being clearly a modern structure. He wanted the lobby areas to be contemporary and simple so that theatergoers entering the auditorium would experience a dramatic change of moving from the 21st century back in time to the 17th century.

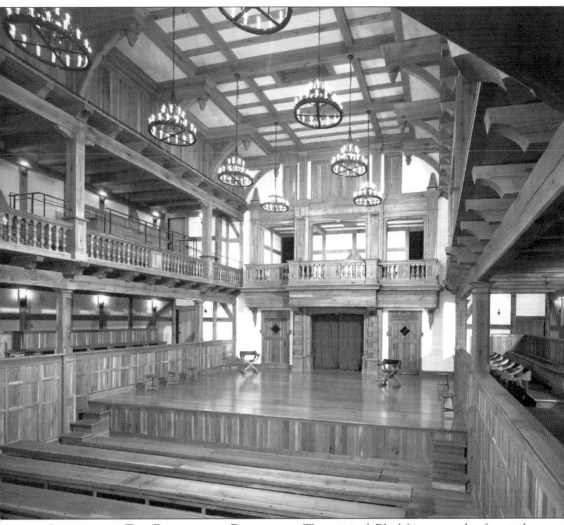

INTERIOR OF THE BLACKFRIARS PLAYHOUSE. The original Blackfriars was the first indoor theatre in the English-speaking world, and it was where many of William Shakespeare's works were originally performed. The Blackfriars had been constructed within the walls of a former abbey, which had been used by monks who wore distinctive black robes: hence the name Blackfriars. The two-story auditorium of the re-created playhouse in Staunton is constructed of heavy oak beams and posts pegged together. The space is lit by large wrought iron chandeliers and sconces made locally by blacksmiths, and it is powered by electricity that mimics the candlelight used in the original London playhouse.